IMAGES
of America

POWDER SPRINGS

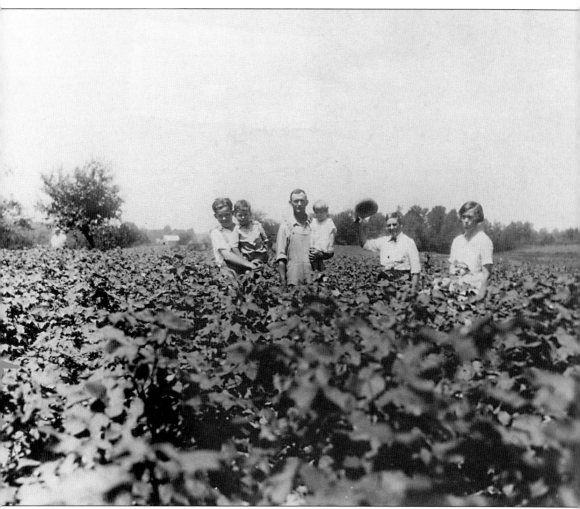

An unidentified family poses in the middle of their cotton field. Powder Springs became the center of a prosperous agricultural region that boasted two gins. The boll weevil's arrival in 1915 killed King Cotton, the chief crop of the area. Farmers were forced to diversify. A cheese factory was established in 1921 but closed its doors two years later because of declining sales.

IMAGES
of America

POWDER SPRINGS

Lauretta Hannon

ARCADIA

Published by Arcadia Publishing
Charleston SC, Chicago IL, Portsmouth NH, San Francisco CA

Printed in Great Britain

Library of Congress Catalog Card Number: 2004111164

For all general information contact Arcadia Publishing at:
Telephone 843-853-2070
Fax 843-853-0044
E-mail sales@arcadiapublishing.com
For customer service and orders:
Toll-Free 1-888-313-2665

Visit us on the internet at http://www.arcadiapublishing.com

Dedicated to the memory of Sarah Frances Miller, founder of the
Seven Springs Historical Society & Museum

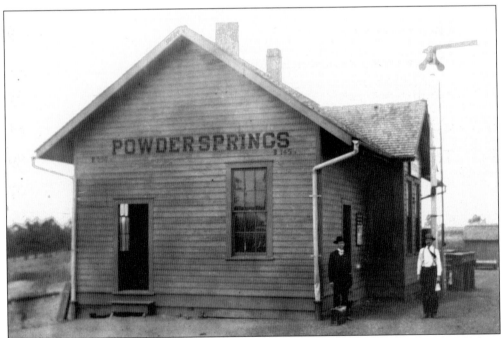

The Seaboard Railroad and Depot was built in 1905 through Powder Springs. It traveled from Atlanta to Birmingham, Alabama. The depot, shown here around 1918, was torn down in 1945. The rail bed is now the Silver Comet Trail, a 59-mile, multi-use trail enjoyed by many in the area.

CONTENTS

ACKNOWLEDGMENTS

Many thanks to everyone who helped make this book a reality, especially Patti Briel. My gratitude also extends to Willie G Watts, Joe Sutton, Beverly Postell, Gloria Hilderbrand, Jeff Jerkins, Dennis Bellamy, Essie Young, Floyd Penn, Doris Turner, Eunice Webb, and Jim Kilgore. A special thank you goes to Imogene Abernathy.

I am deeply indebted to those who have come before me: Roberta Murray, Virginia Tapp, and Sarah Frances Miller. Their research and writings have made this book possible. Thanks also to Eric Jon White II; his *1920 Powder Springs Annotated Census* was a valuable resource.

Powder Springs has always offered a wonderful quality of life. My hope in writing this book is that we will protect this historic way of life in the midst of growth and development.

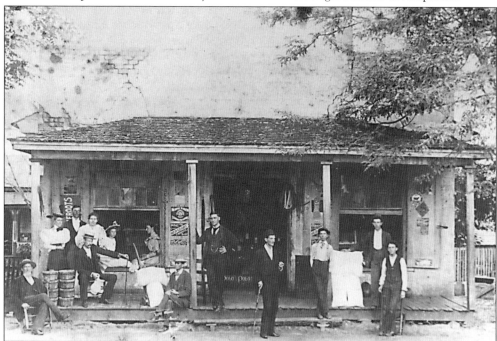

Some of the townsfolk pose in front of John Butner's store around 1900. They are, from left to right, undertaker Uriah Matthews, Emma Florence, Walker Florence, Ida Florence, Tom Butner, unidentified, unidentified, Will Reed, storekeeper John Butner, Dr. John Hunter, Mr. Matthews's son, Garnett Hardage, and Mr. Waltin's father.

INTRODUCTION

The early history of Powder Springs is the history of the relationship between the people and the seven springs located in the area. Before white settlers discovered the beauty of the rolling countryside and the richness of the soil, the springs were well known to both Creek and Cherokee. The Native Americans called the site Gunpowder Springs because of the gunpowder-like sediment that resulted from the mineral content of the spring water. The sediment, smelling faintly of sulphur, was said to be "as dry as powder" when the water ran off. Pioneer families began building log cabin homes as early as 1819, and the village soon became a center for commerce. Gold was discovered in 1828, and in 1838, the Indians were forced to leave on the infamous Trail of Tears.

In December of that same year, the town of Springville was founded. By the late 1850s, Springville was a bustling resort area where people came for the medicinal mineral water. Over a period of 20 years, there were five hotels built in the village, and residents took in boarders to handle the overflow of tourists. By 1859, the name of the town was changed to Powder Springs.

In the summer of 1864, Union troops occupied Powder Springs. Although only minor skirmishes were reported, a band of rough-and-ready Confederate spies kept U.S. Maj. Gen. George Stoneman's men busy during their stay in Powder Springs. The town further felt the affects of war when both the Baptist and Methodist churches were destroyed for their lumber. Two homes were used as field headquarters and hospitals. Because of the town's proximity to several major battle sites, Powder Springs hosted 16 Confederate and Union generals over a 10-day period in the autumn of 1864.

From 1870 to 1920, the town supported a thriving farming economy with cotton as the main crop. Commerce consisted of two gins, warehouses, seed and fertilizer stores, general merchandise and grocery stores, blacksmith shops, barbershops, millinery shops, a hardware and lumber company, an icehouse, a livery stable, and a grist mill. When the boll weevil destroyed the cotton crop in 1915, residents had to find other ways to make a living. Despite the hard times of the 1920s and 1930s, a number of businesses opened downtown, and two railroad lines carried mail and passengers every day. Now known more as a residential community and refuge from Atlanta, Powder Springs continues its expansion while maintaining a distinctive small-town charm.

This postcard of Sarah Frances Miller was taken around 1922. The Seven Springs Museum has some of Miller's childhood clothing on display as well as various other items from her estate.

One

HISTORIC HOMES

The Scott-Rice-Mellichamp-Sgrignoli House, also known as the Ivies, was built by Isaac Newton Scott (1841–1908) and his wife, Louise Ragsdale (1843–1928), around 1866. A National Folk House, the Ivies was one of the oldest houses in town. The First Baptist Church acquired the Ivies, and it was dismantled in 1997 to make room for a parking lot.

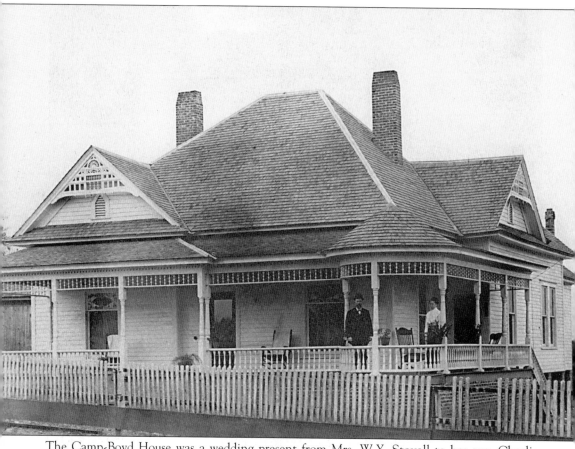

The Camp-Boyd House was a wedding present from Mrs. W.Y. Stovall to her son, Charlie Camp, about 1900. The house includes decorative spindle-work within the gable, lace-like porch supports and balustrades, and a corner tower on the porch. Charlie's wife, Emma, was outraged when state officials informed her that her oak trees would have to be sacrificed for the widening of Marietta Street. Refusing to cut down the oaks, she stood guard on her porch, with shotgun in hand, throughout the road project. The Camps' servants lived directly behind the house at 4280 Atlanta Street. Today the Camp-Boyd House is home to Marilyn's Professional Salon.

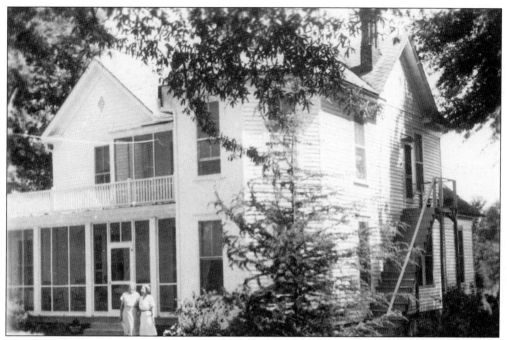

The Bennett-Lewis-Lindley House was located at the current site of the First Methodist Church sanctuary. It was originally the home of the John A. Lewis family. Lewis was the owner of a local cotton gin and grist mill. He was hit by a train and killed in 1926.

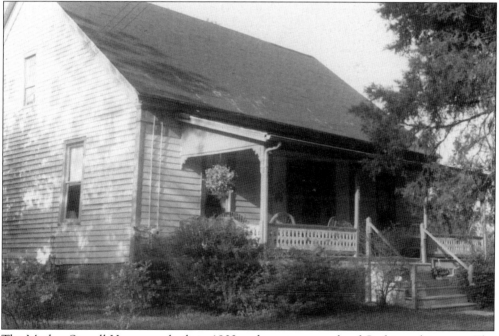

The Mother Stovall House was built in 1902 and was an example of Gothic architecture. The front two rooms were put together with wooden pegs, and the sills were made of trees with the limbs lopped off. Although fire destroyed the house in the 1990s, the large cedar trees in the front yard still stand. The trees are more than 200 years old.

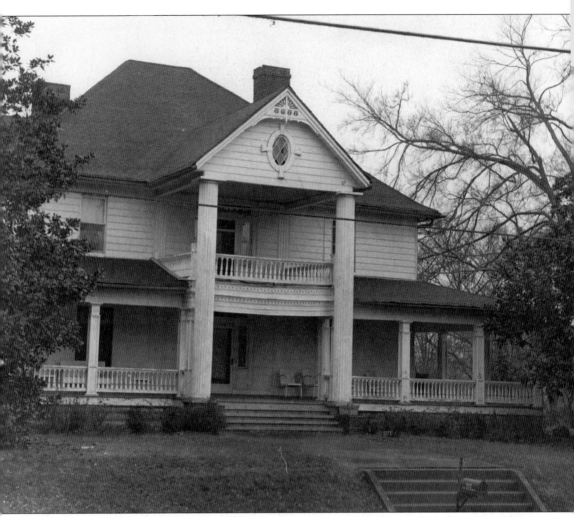

The Camp-Lawler-Magnolia House is an outstanding example of the plantation plains architectural style. It was built in the early 1900s for Tom and Bright Camp on a site somewhat north of where it is now. In 1930, it was rolled to its present position to accommodate the widening of the road. Later residents were Mr. and Mrs. L.C. Lawler and Mrs. Lawler's brother, Harold Norris. The town charter of 1859 specified that the city limits extend in a half-mile radius from a spot that the Lawlers and Norris pinpointed as lying in the center of their entrance hall. Other structures on the site included Dr. Aristides's Rental House and the Stovall Hotel, one of several hotels that flourished when the community was a bustling mineral springs resort. Now a special event facility known as the Magnolia House, the house has undergone extensive expansion and renovation. (Photo by David B. Furber.)

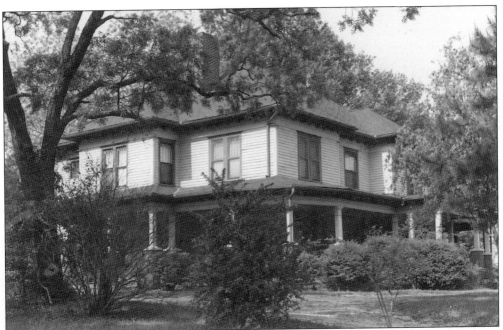

A classic Italianate structure, the McTyre-Hunter-Herrigel House was built by Charles Marshall McTyre, owner of a general store and cotton gin. After watching a salesman demonstrate how to drive an automobile, McTyre decided to purchase the car and drive home for lunch. As he neared his house, he realized that he had forgotten how to stop the car. He drove to Marietta and back and then ran the machine into a tree in his yard. After this experience, he kept the car in the garage except when he wanted to make trips to his farms or to Florida.

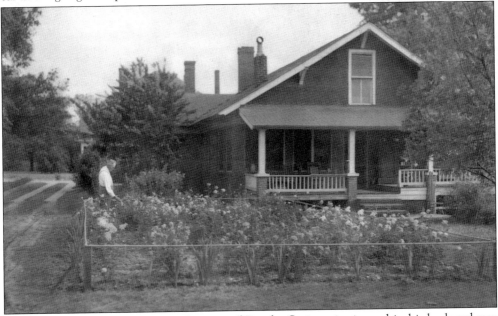

M.A.J. Landers, a businessman and mayor of Powder Springs, is pictured in his backyard rose garden in an undated photograph. The M.A.J. Landers Company sold hardware, building materials, feed, and fertilizer from 1914 to 1936. His home on Marietta Street is now a law office.

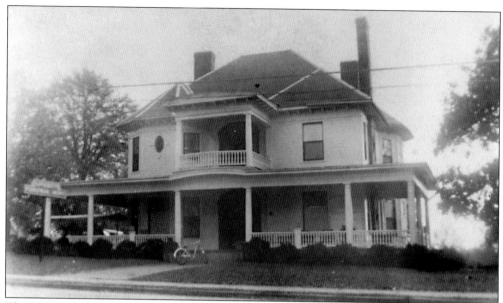

The Florence House (Lindley's and Bellamy's Funeral Home) was built by W.W. Florence and his wife, Ida Butner Florence, around 1915. It has an irregular shaped hip-gabled roof, decorative masonry chimney, classic column supports, and a second-story porch. The house has been used as a funeral home since 1953. Previous owners of the funeral home are Frank Pickens "Pick" Lindley Jr., Gene Davis, and Marion Heyward Turk. Dennis Bellamy, the current owner, has operated the funeral home since 1980.

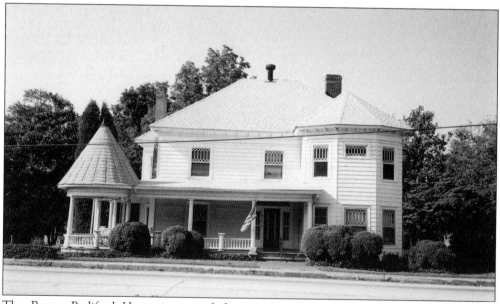

The Butner-Bodiford House is one of the town's most elaborate examples of Victorian architecture. Its classic Queen Anne design features two cross gables, a corner tower, and a decorative wrap-around porch. John L. Butner, an extensive landowner and dry goods merchant, bought the house on the corner of Marietta and Walton Streets from the Marchman family. It was a bungalow with hand-hewn beams. He added a second story and other rooms in early 1900. Robert G. Bodiford bought the house in 1954.

14

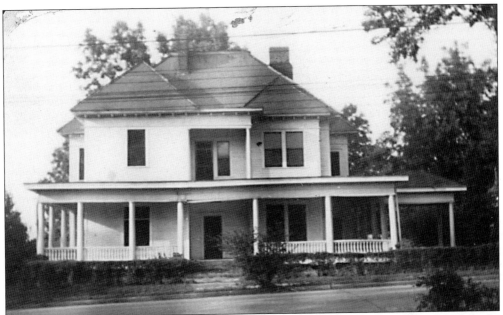

This house was the home of the William Lafayette Florence family. Florence is listed in the 1920 census as a railroad conductor and husband of Agnes Lindley.

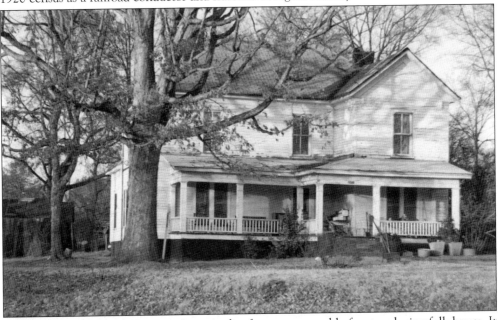

The Leake-Lovinggood House is an example of a two-story gable front and wing folk house. It was built in 1913 by C.T. Leake, a local cotton buyer. After the Leakes moved into the new house, they heard noises at night, and the boys thought the home was haunted. It was soon discovered that the otherworldly sounds came from dogs walking over lumber stacked under the house. Boyd Vaughan, the druggist, lived in the house after buying it from Leake. Virgil Lovinggood, a grocer for nearly 50 years, moved here from Cherokee County. He bought the house and lived there for many years. The house is still owned and inhabited by the Lovinggood family.

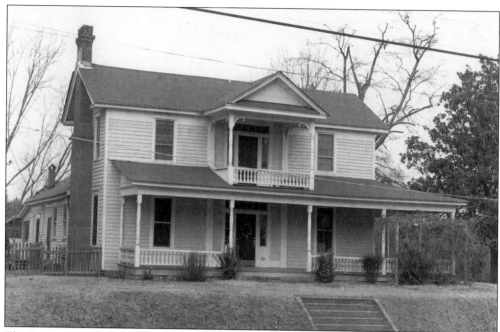

The Scott-Rice-Mellichamp-Sgrignoli House, built by Isaac Newton Scott, has a Confederate connection: Scott was in the 7th Georgia Regiment, Infantry, Anderson Brigade, Hood's Division, Longstreets Corps. He received a leg injury at the first Battle of Manassas. After a period of recuperation, he returned and acquired land from the site of the house, up New Macland Road, to Noses Creek. In modern times, the acreage around the house was known for its lovely old-growth trees and heirloom flowers. (Photo by David B. Furber.)

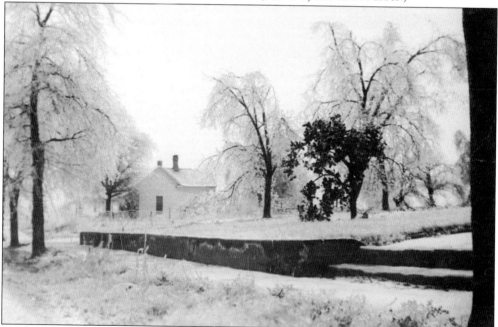

The James C. Vaughan House, built around 1896, is pictured in this wintry scene. Bellamy's Funeral Home is now on the property to the right of this house.

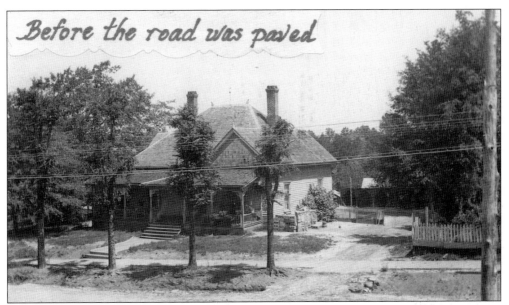

G.D. "Dave" Miller, one of the first rural mail carriers in 1902, bought this house from David McEachern. It was a four-room shotgun house. Two of the rooms were pulled around, and a hall was built between them. As the family prospered, a wrap-around porch and two other rooms were added. David McEachern was the ancestor of John Newton McEachern, for whom McEachern High School is named. The structure is now home to Craig Fine Portraits.

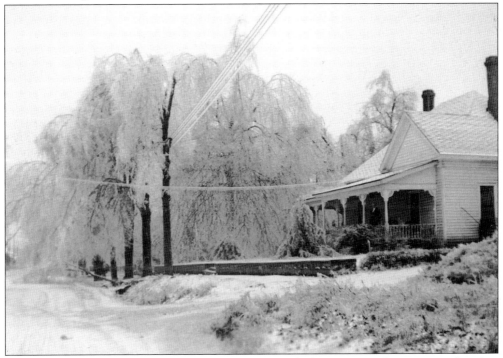

Here is another view of the McEachern-Miller House before Marietta Street was widened in 1928. Notice the rows of water oak trees between the sidewalk and the street. Such trees stood in front of every house on Marietta Street.

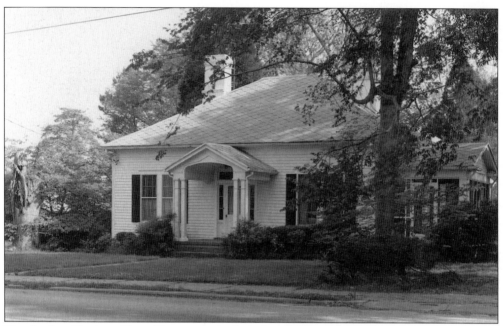

The Lackey-Florence-Tapp House was built before 1877 and was the childhood home of Virginia Tapp, a teacher and compiler of local history. "Powder Springs is older than Atlanta," Tapp said. "We have something here that's worth preserving." She worked with Sarah Frances Miller to record the history of Powder Springs.

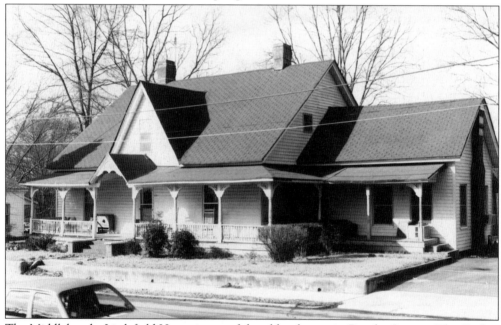

The Middlebrooks-Littlefield House is one of the oldest homes in Powder Springs. The Gothic revival house was probably built around the time of the Civil War. Dr. J.D. Middlebrooks purchased the house in 1900, moving his office there from a downtown location. The current owners have made two interesting discoveries: a pouch of Confederate money that had been cemented in the chimney and an 1886 silver dollar hidden in the ceiling.

18

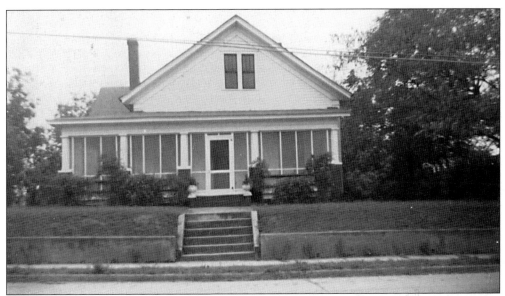

The H.C. Miller House is a Craftsman bungalow built for Harry Cole Miller in 1920. Miller was a rural mail carrier in Powder Springs from 1918 to 1928. Miller and his wife, Ethel Leake, had one daughter, Sarah Frances. She lived in the house until her death in 2002. It is now home to Judith Ann Photography, and a plaque inside honors Sarah Frances.

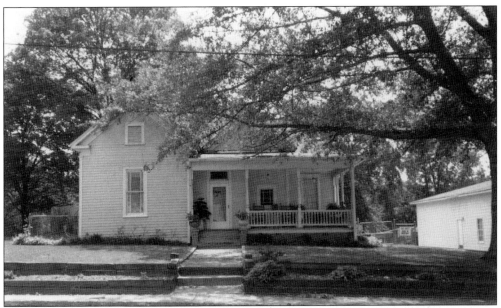

The Bookout-Vaughan-Petree-Smith House was built in 1896. While recovering from pneumonia, Boyd Vaughan, son of Dr. J.S. Vaughan, wanted to go to a Friday-night square dance. Dr. Vaughan did not think this a good idea, so he had his wife, Maggie, hide Boyd's shoes, thinking this would keep the boy at home. The next morning Boyd was huddled by the fire. His father noticed that there was a big hole in the sole of each bedroom shoe—he had danced in his bedroom shoes.

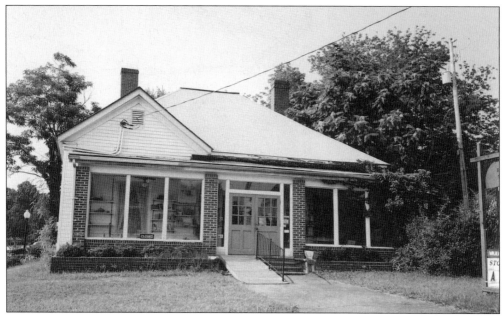

The Matthews-Lindley House, now Owl's Tree Bookstore, was the home of Uriah Matthews, the first undertaker in Powder Springs. He was in the funeral business from the 1850s to 1901. In those days, the undertaker furnished the coffin, and a quilt to cover it, as it was carried to the church or cemetery. Neighbors and friends handled the rest: furnishing a wagon, digging the grave, lowering the casket, and filling the grave. Thomas Newell Lindley, known as Uncle Tom, took over the business from Matthews in 1901. Lindley's grandson would follow him in the business.

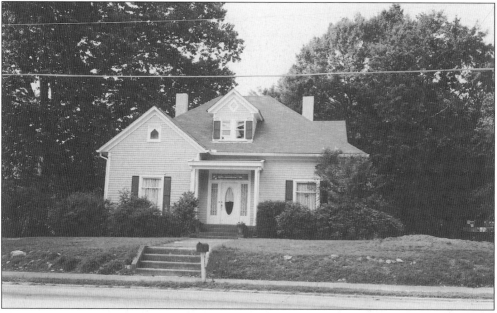

The Florence-McTyre-Conlon House was built in the early 1900s by Wallace Florence, a cotton buyer. The story-and-a-half house has a beautiful oval-glass front door. When the Florences moved to Cedartown, J.B. McTyre bought the house and renovated it.

The Murray House on Atlanta Street was built as a duplex for Dr. Robert Root Murray's daughters, Mina and Roberta. Dr. Murray came to Powder Springs from his home in Watkinsville to practice medicine about 1860. He also served as a lieutenant in the Confederate Army. His daughter Roberta Murray is known as the town's first historian.

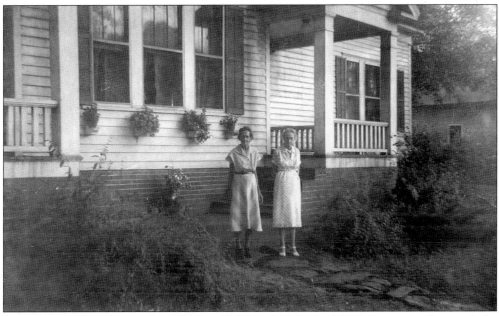

Dr. Murray's daughters, Mina Turner (left) and Roberta Murray, pose in front of the Murray House.

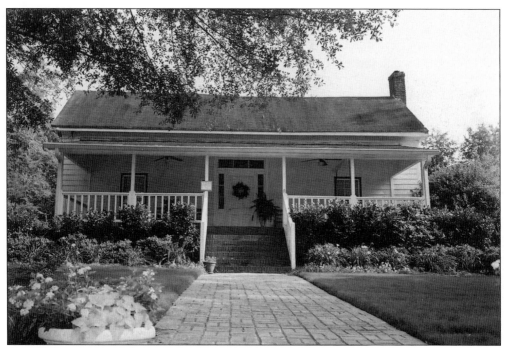

King William and Beulah Spratlin built this house on Atlanta Street. They had two sons, Ralph and Clyde. Mr. Spratlin owned a grocery store downtown. An undated advertisement from Spratlin's store offers 15 pounds of sugar for $1.

Georgia Estes bought this house in 1929 and lived there with her grandchildren, Helen and Jim Hammond. A turn-of-the-century corn crib still stands in the backyard. Helen recalls playing under the large oak tree, which shades the driveway today.

The Miller House is a one-story, front-and-wing folk house. Although the homes on Atlanta Street are more modest than those on Marietta Street, they offer architectural variety. Among the homes on Atlanta Street are three Craftsman bungalows from the 1920s.

This hall-and-parlor folk house was the home of Benjamin Lafayette Hilley, a restaurant proprietor. He described his restaurant as the "headquarters for cold drinks and hot lunches." In the 1930s, his was the only house on the block to have telephone service.

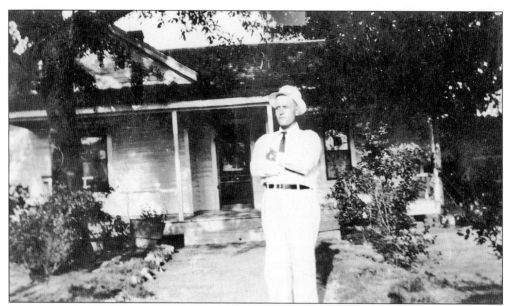

Oliver Lee "Ollie" Hill stands in front of his home on Old Lost Mountain Road. Hill operated a grocery store on Old Lost Mountain Road and was the father of baseball great Johnny Hill.

This house on Old Lost Mountain Road was built around the turn of the century. Beatrice Maddox Still (left), Viola Maddox (center), and Wofford J. Maddox stand in front of their home. Beatrice Maddox Still has fond memories of family Christmas gatherings at the home. On cool, rainy nights, her uncle, Johnny Hill, would stop by for his favorite meal: oyster stew, crackers, and ketchup.

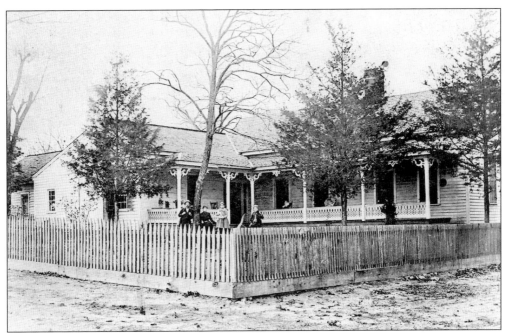

The Wiley J. Kiser House on Old Lost Mountain Road was occupied by W.J. Tapp and
? Mozley. Later, Willie Jennings and his family lived there. The house was later moved to
Westville, Georgia.

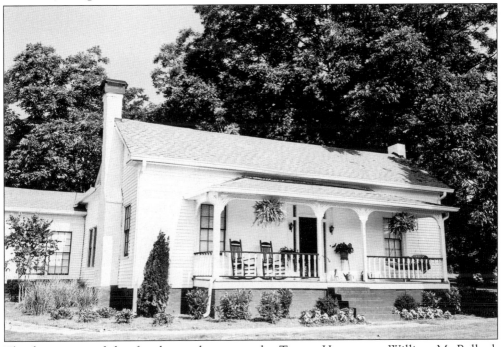

The first owner of this farmhouse, known as the Turner House, was William M. Bullard.
He married Lucy Ellen Moon, and they raised their eight children in the four-room home on
Old Lost Mountain Road. In 1939, Mr. and Mrs. Cecil Turner bought the house and added
three rooms.

This five-room farmhouse was built before 1900 by Reuben Hill on his family farm. The original farm was 60-and-a-half acres. The Hill family farmhouse was situated in front of the present house and was torn down. Many residents remember the strawberry field across the street from the house. The house, located on Old Lost Mountain Road, was later beautifully restored by Mr. and Mrs. Bill Mosely.

Gladston Farms was the home of John Newton McEachern Jr. The 1,000-acre farm was homesteaded by his grandfather, David Newton McEachern, in 1831. His father, John Newton McEachern Sr., co-founder of the Life of Georgia Insurance Company, was born there in 1853. In the 1940s, McEachern restored the Macland Road home to its original beauty and stocked the farm with hogs, Shropshire sheep, and a stable of registered Tennessee walking horses.

Two
DEAR HEARTS AND GENTLE PEOPLE

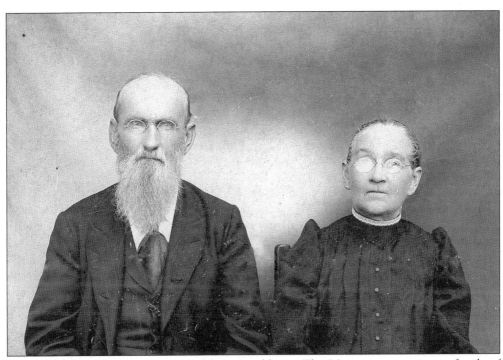

Isaac and Maggie Moon are pictured here in old age. The Moons were a pioneer family of Powder Springs. Educated as a physician, Isaac Moon went on to become a farmer and Primitive Baptist minister. He represented Cobb County in the lower house of the Georgia General Assembly from 1885 to 1887.

This portrait painting of beautiful Margaret Callaway Florence (1861–1946) was based on a photograph taken in 1878. The painting was created in the studios of the Fine Arts Association in Chicago in 1935. Margaret was the wife of Alexander Warren Florence.

Eloise Florence Nestlehutt (1890–1934) was the daughter of Warren and Margaret Callaway Florence. This photograph was taken in 1891.

J.W. Miller and his wife, Mattie, pose for a studio photograph. Notice the avian-inspired hat.

The Leakes were another Powder Springs pioneer family. This photograph is believed to be of Bryant J. Leake and his granddaughter, Emma Dent Dodd.

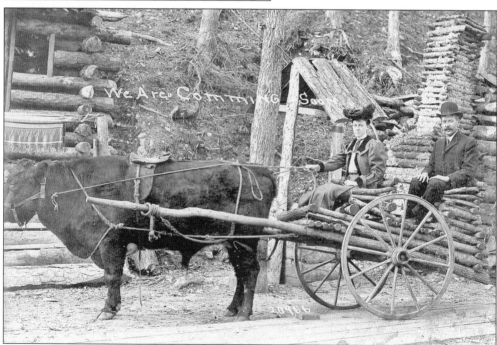

Fannie and Wallace Florence commemorated their honeymoon in Hot Springs, Arkansas, with this light-hearted photograph. Mr. Florence was a cotton buyer in Powder Springs.

This wedding photograph of Fannie Itillia Lindley Turner and William Robert Turner was taken on December 23, 1880. They rest in the Methodist Cemetery.

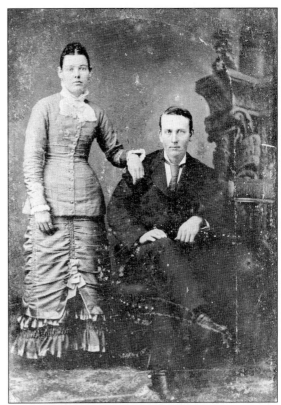

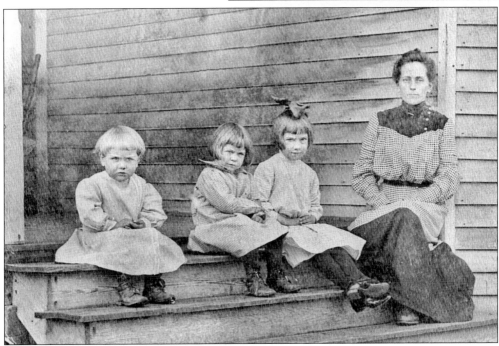

Maude Conger McTyre sits on her Marietta Street porch with daughters, from left to right, Dottie, Mearle, and Lucille.

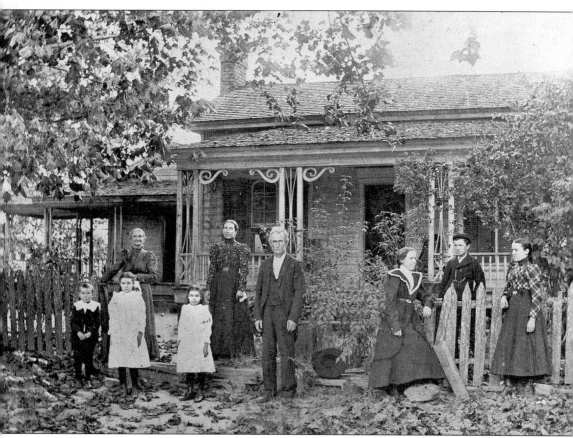

Jim Mann and his family are pictured at home on Brownsville Road. Billy Florence built the house in 1872. The majority of early settlers came from Virginia and the Carolinas in search of more land. Between 1830 and 1840, several of the founders of the present town settled here. Among them are to be found the names Anderson, Baggett, Bennett, Du Pre, Florence, Hopkins, Hunter, Hicks, Lindley, Ragsdale, Reynolds, and Scott.

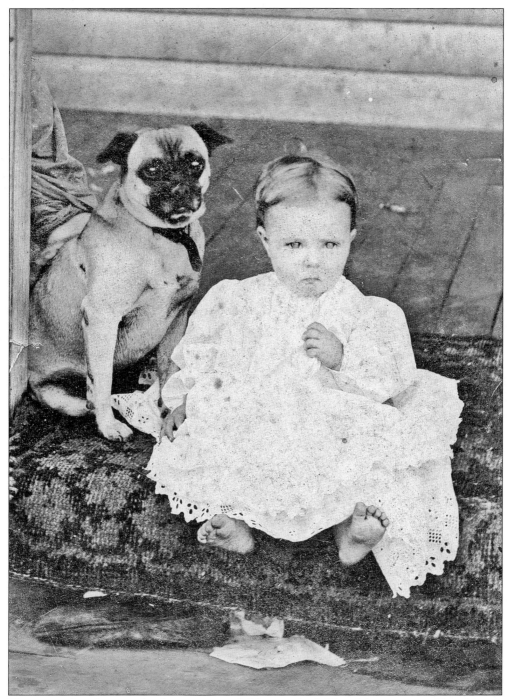

The pug in this photograph is keeping a watchful eye on little Katie Moore, niece of Jake Moore.

Martha Luella Compton and Madison Warren Compton, pictured c. 1900, were the parents of Thomas Newton Compton, Hattie Tuck, and Lizzie Weeks. Thomas Newton Compton was mayor of Powder Springs from 1957 to 1962 and from 1967 to 1970. Compton Elementary School is named in his honor.

From left to right, Harvey Mayes, Lillie Bell, Homer Green, and Ada Lewis sit in a shady front yard in 1890.

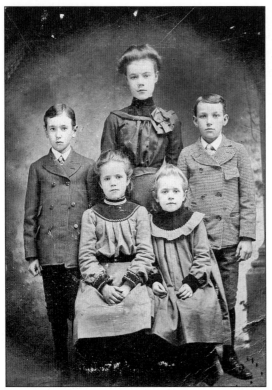

The children of Dr. James Shelton Vaughan gather for a studio photograph around 1899. Pictured from left to right are Boyd, Siddie, Mamie, Josie, and their cousin, Tom Poole. The Vaughan family arrived in Powder Springs in the late 1880s. Dr. Vaughan practiced medicine until ill health forced him to retire in 1927.

All we know about this pretty little girl is that she was two years and nine months old when the photograph was made on August 2, 1898.

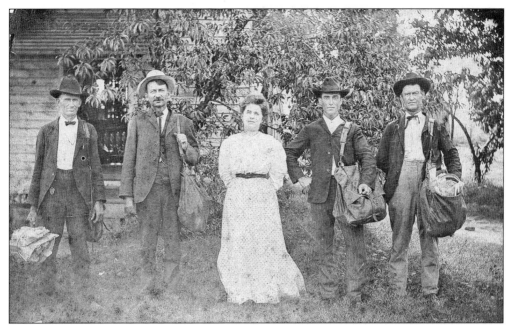

The town's first rural mail carriers are pictured in 1902. Standing from left to right are John McKinney, Dave Miller, Belle Wright, Clem Chandler, and Bud Moon. Miller was the grandfather of Sara Frances Miller, founder and leader of the Seven Springs Historical Society & Museum until her death in 2002.

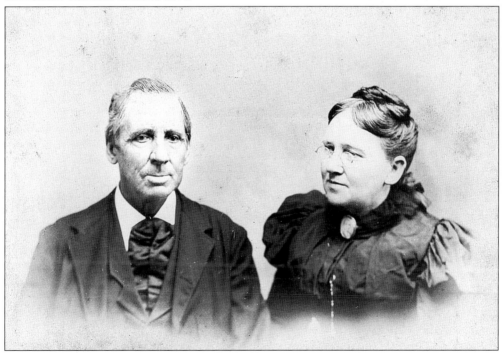

John Calhoun Butner and Lucy Elizabeth Lindley Butner, pictured in August 1898, were the parents of John Lindley Butner and Dr. William Edgar Butner. The Butner brothers were prominent figures in Powder Springs.

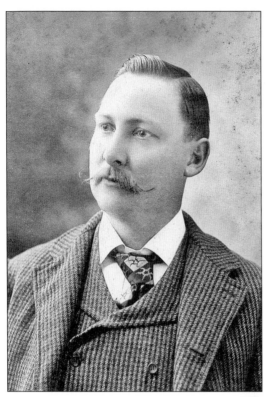

Dr. William Edgar Butner (1868–1927) married Eva Hendrick (1871–1952). They were the parents of Gladys Butner Jennings and John Hendrick Butner.

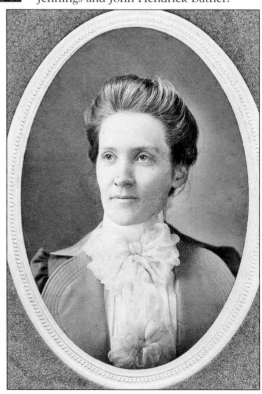

Gladys Butner Jennings, pictured around 1913, sports a fashionable hairstyle of the era.

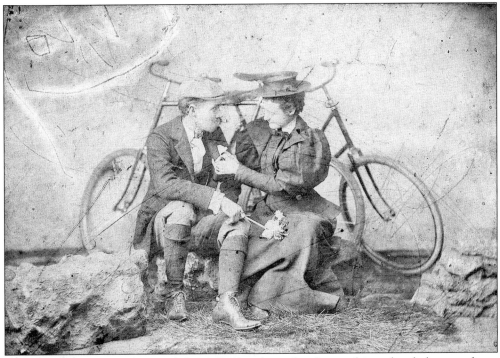

A young man and woman record their affection for each other in this undated photograph.

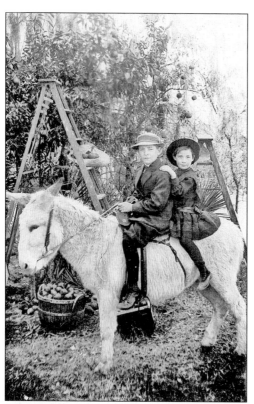

Robert Roy and Elizabeth Butner sent this postcard to their uncle in 1912. Their message reads, "Dear Uncle Tom, Our car broke down but you see we got a mule to ride."

Bob Lindley takes some friends out for a spin in this undated postcard. Lois Bookout, Lindley's future wife, is in the front seat. In the back seat, from left to right, are Beatrice Bookout, Leo Miller, and Mary Belle Legg.

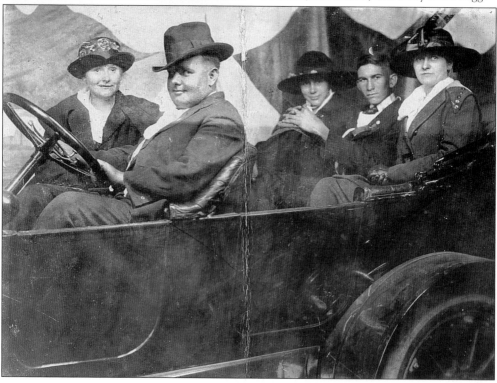

Six-year-old James Oglesby strikes a patriotic pose in 1919. His parents, J.B. and Ocie Oglesby, lived on Brownsville Road. Mr. Oglesby was a banker.

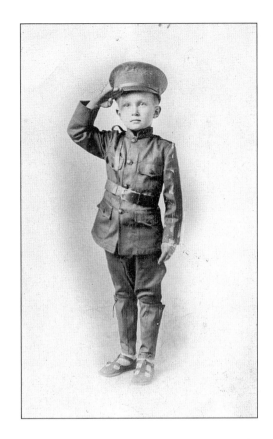

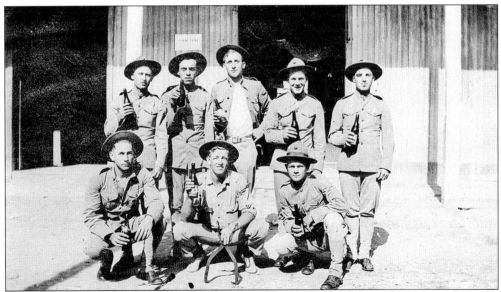

Ralph McTyre, at left on the front row, pauses with his Marine buddies during World War I.

Eloise Florence Nestlehutt is pictured around 1900.

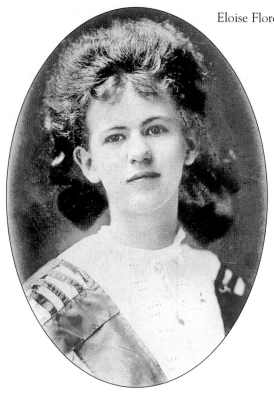

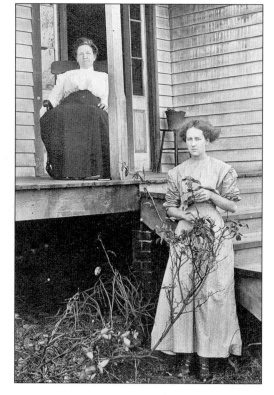

Georgia Lindley Murray (left) and her daughter, Mina Murray Turner, are pictured at their old home place on Atlanta Street. Mina's sister, Roberta Murray, lived there until her death in 1972.

Roberta Murray was a well-known and respected citizen who spent her life serving others. Long before there was a public library in Powder Springs, Murray invited young people into her own private library and encouraged them to borrow her books. An advocate of education, she often bought shoes and clothes for children so that they could attend school. She is also remembered as the town's first historian.

Dr. and Mrs. J.D. Middlebrooks are shown in front of their home on Marietta Street about 1910. Dr. Middlebrooks bought one of the first automobiles in the community and had a reputation for driving at high speeds and occasionally wrecking the car, once through the back wall of his own garage. Sadly, his 32-year-old son, John, died when his automobile collided with a mule-driven wagon in 1921.

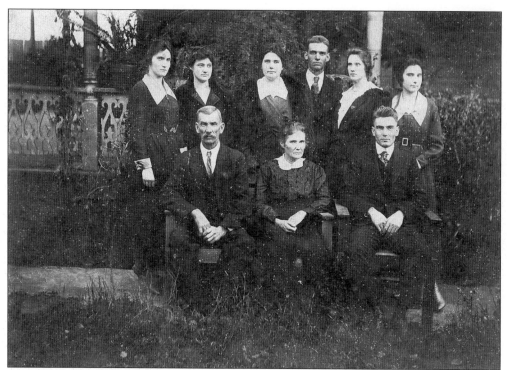

The John A. Lewis family is pictured in 1915. Lewis owned a cotton gin in Powder Springs. His home was on Marietta Street where the First Methodist Church sanctuary is today.

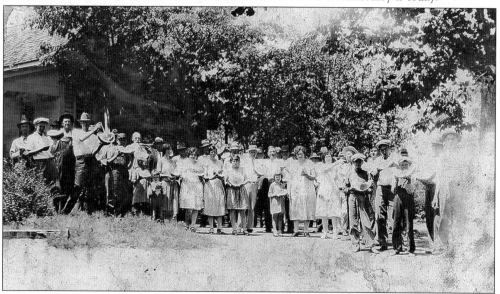

Each year, John Butner held a watermelon cuttin' for his tenants. Among those pictured, not in any particular order, are Frank Leake, John Butner, Lucille Cornwell Doss, Beulah Cornwell, Cliff Geiger, Mrs. John Butner, Cecil Williams, Paul Steed, Buck Nestlehutt, Mr. Elsberry, James Cornwell, Hiram Standridge, Ralph Standridge, Jack Stewart, Louise Turner, Thomas Turner, Marsh McTyre, Kate Steed, Gladys Hendrick Hardy, Mr. Scott, Jewell Hendrick, and Runelle Hendrick Cornwell.

The Geiger family sharecropped for John Butner. From left to right are Noel and Anna Still (Mrs. Geiger's brother and his wife); John Clifford Geiger holding Martha Kate; John Clifford Still Jr. in front of his mother, Cleo Still Geiger; and Emmett Geiger. This 1930 photograph was taken when they lived at the Garrard House on Hiram Lithia Springs Road. Emmett Geiger is the father of Betty Brady, longtime city clerk of Powder Springs.

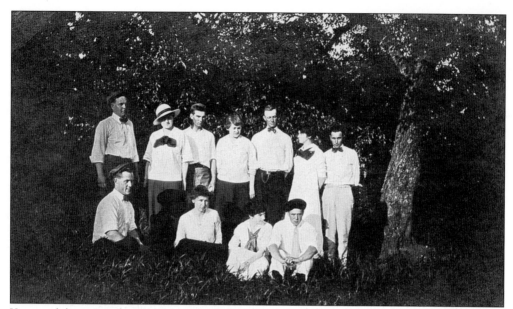

Young adults in Powder Springs enjoyed getting together for picnics and gatherings at the park. Pictured, from left to right, are the following: (front row) Tatum Rice, Mina Murray, Emma Lewis, and Frank Chandler; (back row) Bob Lindley, Estelle Tapp, Coy Lewis, Beatrice Bookout, Hubert Lindley, Hettie Lewis, and Boyd Vaughan.

Lenda Brooks, daughter of Cliff and Hattie Landrum Brooks, is all sugar and spice in an undated postcard. Her parents were sharecroppers who lived in the first district.

This postcard shows Annie Stokes, described as a very close friend of the Brooks family in Powder Springs. (Courtesy Georgia Division of Archives and History, Office of Secretary of State.)

A fun-loving group is pictured in 1938. They are, from left to right, Margaret Nestlehutt, Evelyn N. Pace, and Sarah Nestlehutt.

These well-dressed ladies are, from left to right, Mother Maggie Florence, Ethel Stancil, Lucille Florence, and Kathryn Florence.

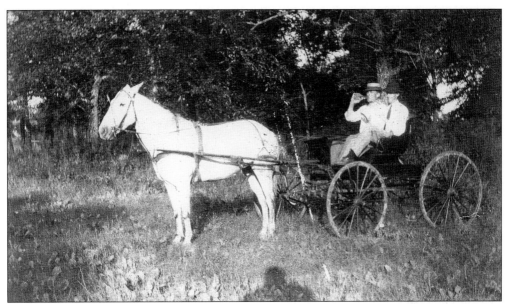

Clarence Du Pre, holding a drink, and Hershel Reeves enjoy an outing in rural Powder Springs.

These young men just want to have fun. They are, from left to right, as follows: (front row) Frank Lindley, Clarence Du Pre, and Marshall Baggett; (back row) Grady Nestlehutt, Fred Cotton, and Jack Baggett.

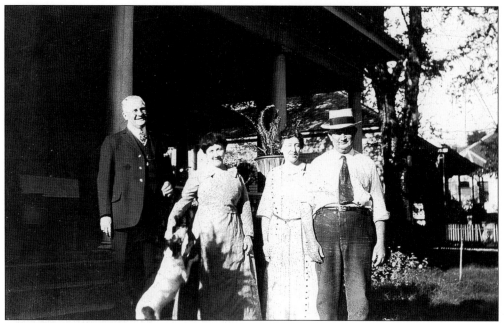

W.L. Florence, pictured at left, owned a construction company that built many Georgia highways. He is seen here with, from left to right, his wife, Agnes; his sister, Emma; and his brother-in-law, Mitch Lindley, in 1925.

The Holbrook clan gathers for a group photograph. They are, from left to right, as follows: (front row) Mr. ? Holbrook, Harold, Ruth, and Mrs. ? Holbrook; (back row) Mary, Elizabeth, Ed, Anna, Tim, and Lena.

Imagine the time it took to get Mittie Lou Leake's curls just perfect for the photograph. She is seen here in an undated postcard.

Hope Callaway Stancil was the sister of Margaret Eloise Callaway Florence. She is pictured, with purse in hand, in an undated postcard.

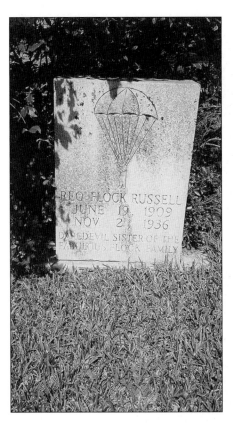

Reo Flock Russell was a stunt parachutist and aerial wing walker with a barnstorming air show in the 1930s. She was the sister of Tim Flock, one of the early legends of NASCAR. Reo and her eight daredevil siblings were known as the Fabulous Flock Family.

Willie May Brown (right) and a friend pause during an automobile outing in 1927. Traveling on dirt roads could be a bit arduous. In the 1920s, 25 miles per hour was considered a top speed.

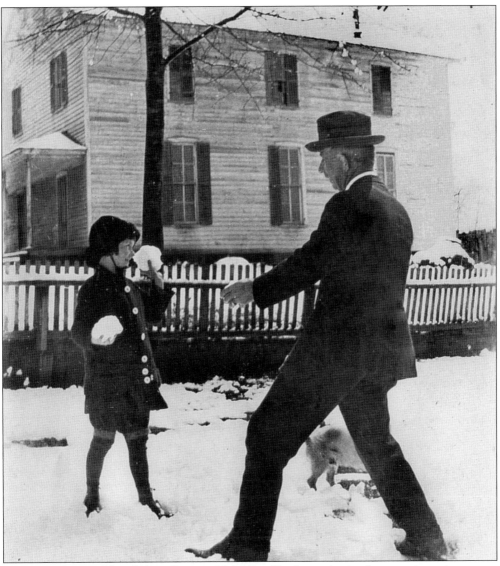

Helen Hardage and her father, Garnett McMillan Hardage, play in the snow in a picturesque photograph from the early 1920s. From 1872 until 1915, the building behind them served as the Methodist church and the home of the Springville Lodge #153 of Free and Accepted Masons. The lodge is now located on Highway 278.

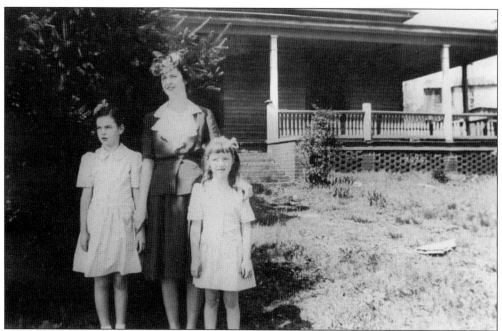

Lizzie Compton Meadows Weeks visits the old Compton home with her daughters, Joyce (left) and Mary. The house stood on the property of what is now Independent Bank.

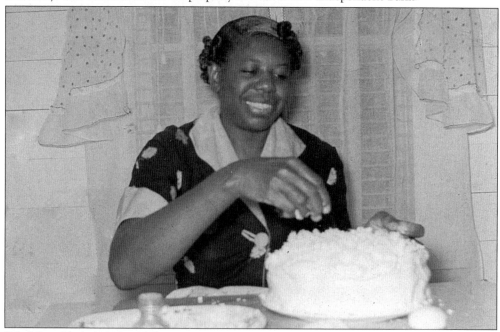

Ethel Lee Clark (1912–1993) prepares a coconut cake in her Butner Street kitchen in 1956. According to a newspaper article about her in the 1970s, "Ethel Clark is one of the most sought-after professionals in Powder Springs. She is not a doctor or a lawyer but her skill as a baker is famous." She was as beloved for her friendly personality as for her trademark five-flavor pound cake and fried pies. Her niece, Willie G Watts, carries on the tradition today from her own kitchen, next door to her aunt's old home. (Courtesy Willie G Watts.)

Charity Young Penn was the daughter of Sandy Young, a popular barber who practiced his trade downtown in the Lewis Building. Charity, a servant of Emma Camp for 27 years, began working for Mrs. Camp when she was just nine years old. She married Luke Penn in 1913, and they had 14 children. Their daughter Doris Turner lives on Atlanta Street on the site of Rev. Alec Penn's house. (Courtesy Floyd Penn and Doris Turner.)

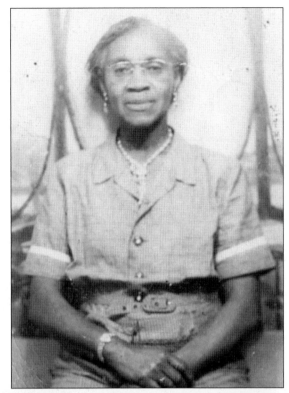

Luke Penn, sitting at right below, was the janitor at Powder Springs School for 40 years. He was the grandson of the Reverend Alec Penn, a prominent religious leader in Cobb and Douglas Counties. Pictured with Mr. Penn, from left to right, are (kneeling) Grady Moss; (standing) Mack Foster, James Penn, Horace Penn, George Mucker, and Andrew Jackson Penn. (Courtesy Floyd Penn and Doris Turner.)

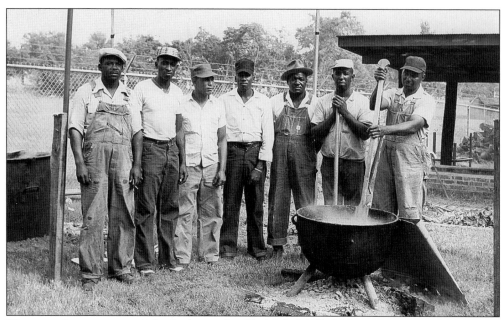

These gentlemen prepared the barbecue for Clarkdale Mill's 25th anniversary celebration in 1958. Standing, from left to right, are Luther Arnold, Melvin Bostic, Ervin Penn, Joseph Burr, Rufus "Coot" Luster, Roger Pinkston, and Willie Foster.

Archie Watson Young (1918–2001) was a second baseman for the Atlanta Black Crackers and a well-known community leader. During his 20s, Young would take time off from his job as a porter at Southern Railway to play baseball for little or no pay. He was a deacon at New Hope Missionary Baptist Church and served a term as vice president of the Cobb County branch of the NAACP. (Courtesy Essie Young.)

Three
SMALL-TOWN LIFE

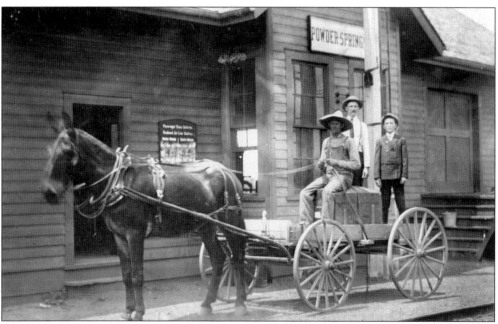

The Southern Railway Depot, pictured here, was built in 1882 and demolished in 1973. The railroad helped put Powder Springs on the map. The Southern Railroad, also known as the East Tennessee, Virginia, and Georgia Railroad (now called the Norfolk Southern Railroad), traveled from Atlanta to Chattanooga, Tennessee. (Courtesy Georgia Division of Archives and History, Office of Secretary of State.)

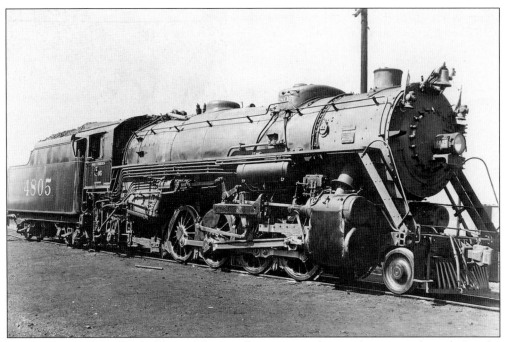

This was one of the fleet of powerful steam locomotives that made its way through Powder Springs. The locomotive could pull 1,800 tons northbound and 1,600 tons southbound.

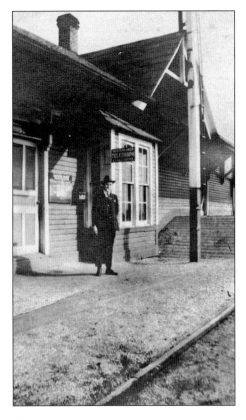

S.E. Smith, depot agent from 1894 to the 1930s, stands in front of the Southern Railway Depot.

Young women await the 3:15 p.m. train in this 1915 photograph. From left to right are Eva Lewis, Ethel Leake, Jo Vaughan, and Betsy Scott.

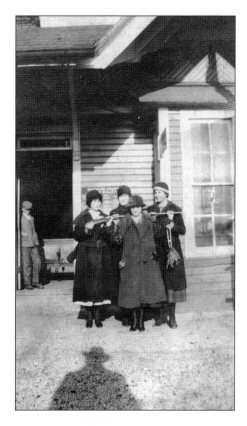

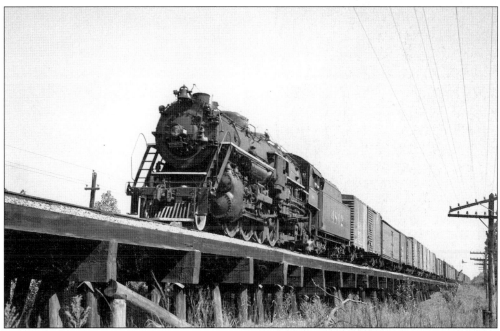

This 1948 photograph shows the Southern 4802 heading north, just south of Powder Springs, over Sweetwater Creek.

John Lindley Butner sent this postcard in 1912 to his brother Tom in Florida.

Barns were a common sight around Powder Springs. This barn belonged to Dr. Robert Root Murray.

This barn, located behind a house on Murray Street, still commands attention as a visible remnant of the town's agricultural past.

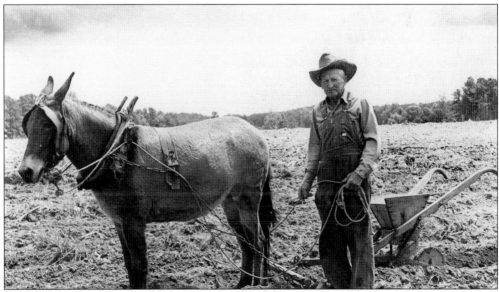

Herman Rutherford, a lifelong bachelor, worked his farm on Bullard Road until his death in 1982. His brother, Harold Rutherford, said, "He dearly loved the simple quiet life."

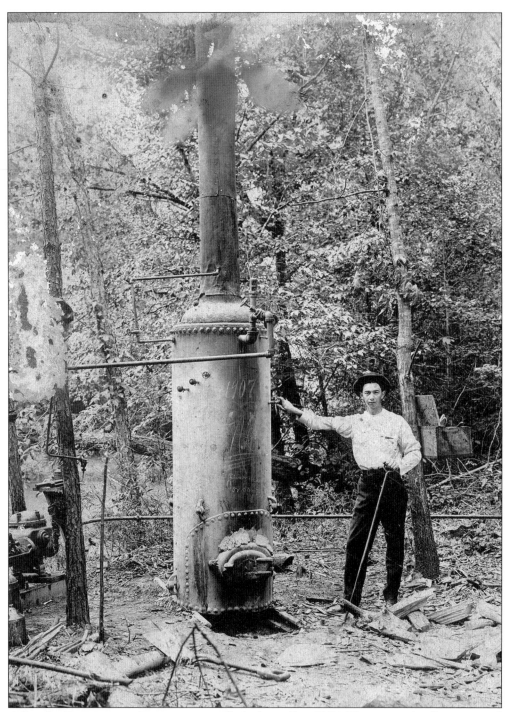

A Powder Springs moonshiner poses proudly by his still in 1907. There were distilleries around town, but they had to be located far from schools and churches. During Prohibition, there was a vacant house on Powder Springs Road that was visited frequently. In the kitchen was a loose board that patrons would lift up, remove a jug of moonshine from below, and then leave their money in the hole.

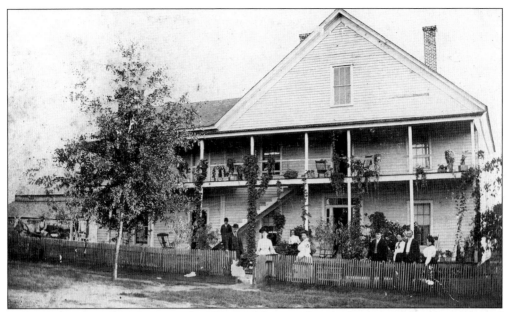

In the 1850s, the village became a bustling health resort for people interested in the medicinal properties of the town's mineral water. The three-story Lindley Hotel, seen here in an undated photograph, hosted many a guest and was prized for its good food and service. George White wrote in 1854, "Powder Springs are twelve miles west of Marietta. They are highly impregnated with sulphur and magnesia, and are efficacious in the cure of diseases, particularly those of cutaneous character, and dyspepsia."

Jimmie G. Landrum relaxes in front of the Powder Springs pump in this undated photograph. The spring pump and the nearby pavilion have been the scene of picnics, fish fries, and dances for 150 years. In the late 1800s and early 1900s, a colorful group of gypsies, or Irish horse traders, would camp at the park each year to sell lace and, of course, trade horses. The pavilion and pump are located in Powder Springs Park on Brownsville Road.

The Lewis family horses around in the park in this undated photograph. Notice the pavilion in the background.

An unidentified young man poses in front of the pavilion in 1921. The park, home to the Seven Springs Historical Society & Museum, is still a hub of recreational activity.

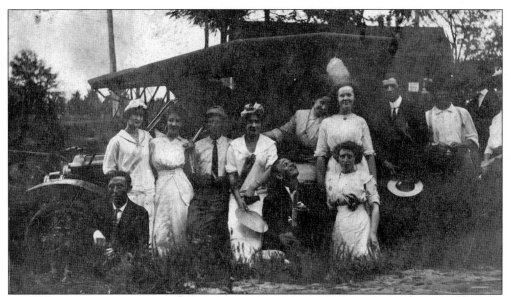

The "picnic crowd" stops for a photograph in the park. Park visitors of all ages would wade in nearby Powder Creek and load their picnic baskets with blackberries and other wild fruits.

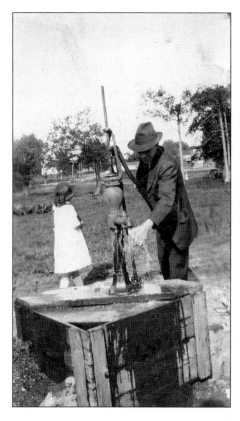

Mr. Holbrook collects spring water from the town pump in this undated photograph.

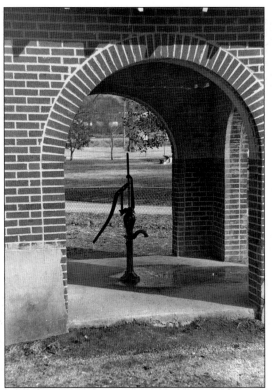

The pump is shown here as it looks now at Powder Springs Park. The city logo features the pump, a fitting symbol of Powder Springs's history. In the early days, the pavilion was at the site of the brick pump house. (Photo by David B. Furber.)

The flooding of Powder Creek was a frequent problem, as seen in this photograph from the 1940s. (Courtesy Georgia Division of Archives and History, Office of Secretary of State.)

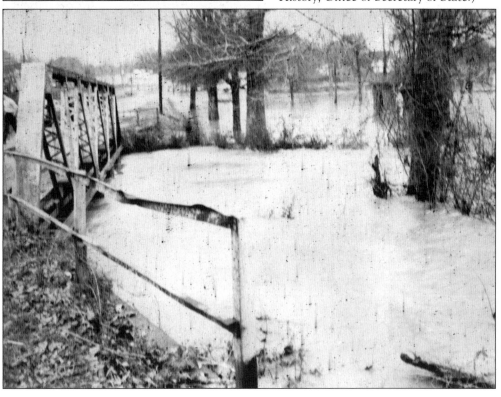

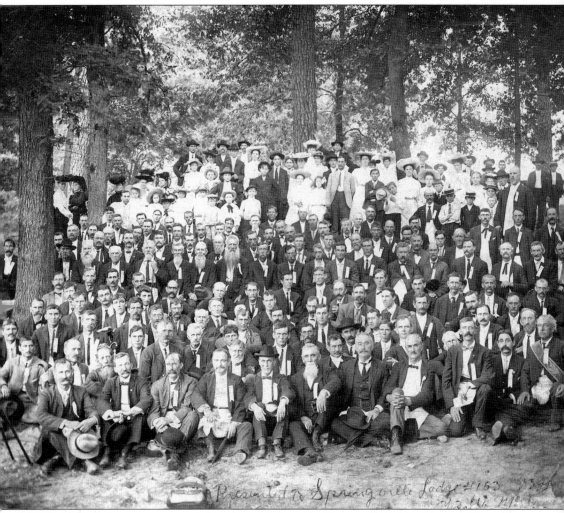

Presented to Springville Lodge #163

This unidentified group presented this photograph to the Springville Lodge Masons. They are probably pictured at the park. Excursion trains were run on Southern Railway to Powder Springs and brought many groups and clubs from Atlanta. In 1894, the Confederate Veterans Association Infantry had a picnic in the park.

The Lewis Building, seen here from the back, was built in 1910. The downstairs has housed a variety of businesses, such as Sandy Young's barbershop. Those occupying the upstairs were the Masons, the Oddfellows, and the Ku Klux Klan. Today the building is home to Powder Springs Flowers and Gifts, whose customers have included Dolly Parton, Bill Cosby, and Paul Newman.

The Springville Lodge #153 of Free and Accepted Masons celebrated its 100th birthday in 1948. Pictured, from left to right, are G.D. Miller, Harold Thomas, Brannon Thomas, and Harry C. Miller. The Masons met in the Lewis Building until 1977, when they moved to their present location on Highway 278 in Powder Springs.

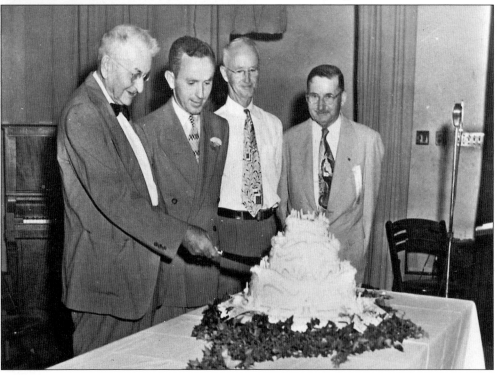

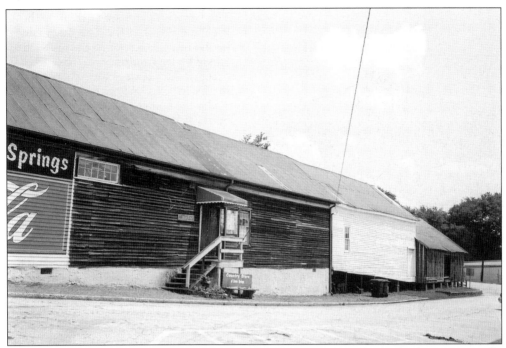

If walls could talk, this downtown building would have a lot to tell. The back was reportedly built in the 1830s and was used as a livery stable during the village's heyday as a health resort. Later it became a stagecoach stop and a storage facility for cotton and feed.

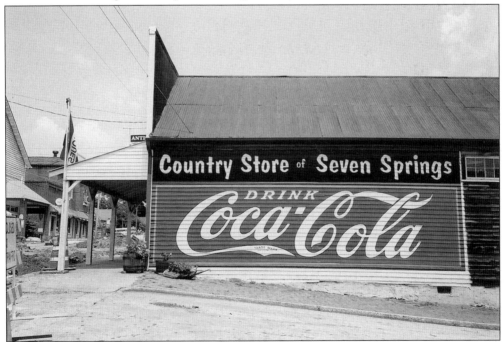

The front of the building was constructed in 1890. Dr. William Edgar Butner operated a store there. Now known as the Country Store of Seven Springs, the current owners have carefully preserved the historic structure.

The building pictured at center is the old Powder Springs Bank (1904–1929). According to a poem printed in the *Powder Springs Pioneer* in 1910, "The clever cashier at the Bank, Is always courteous and polite; And to transact business there, Affords much pleasure and delight." Tapp's Grocery was in the building at right.

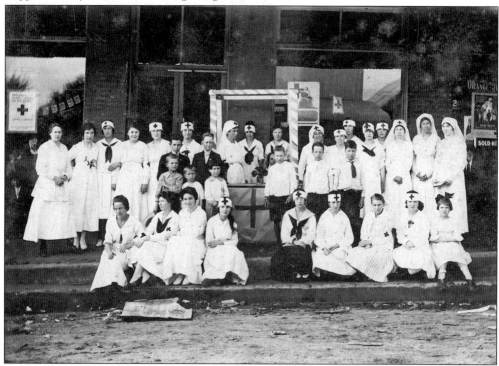

The Powder Springs chapter of the Red Cross gathers for a photograph in the summer of 1918. Red Cross chapters sprung up across America during World War I.

Tom Camp owned the Crescent Swimming Pool and Pavilion from 1920 to 1930. Located north of the town square, the pavilion offered Saturday night dances and live music "for the younger set."

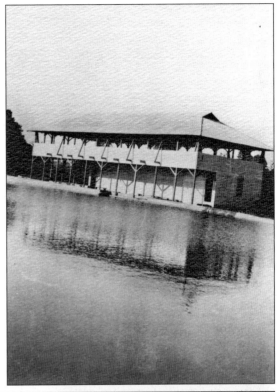

Powder Springs has always been crazy for baseball. The Seventh District A&M team is pictured in 1914 on what is now the site of McEachern High School.

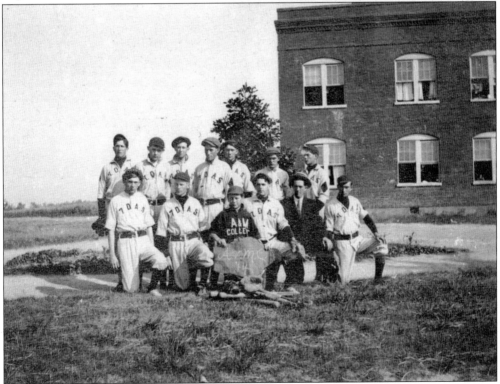

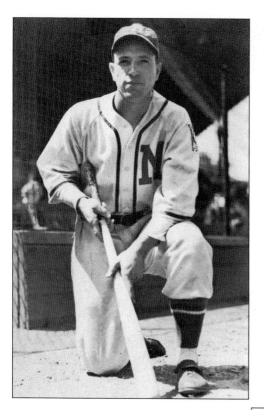

Baseball great Johnny Hill was born and raised on a farm on Old Lost Mountain Road. He is remembered as a short, powerful hitter whose .338 average sparked the Atlanta Crackers to win the pennant, play-offs, and Dixie Series in 1938. He was discovered while playing amateur ball and signed by the Crackers for $250. In 1939, while playing for Milwaukee, he won the American Association batting trophy with a .332 average. Moving on to San Diego, he set a Pacific Coast League record in 1942 by striking out a mere three times in the season.

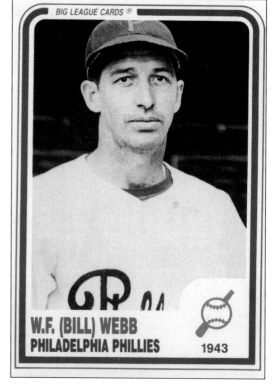

BIG LEAGUE CARDS ®

W.F. (BILL) WEBB
PHILADELPHIA PHILLIES 1943

Bill "Lightning" Webb was a brilliant pitcher who had the distinction of playing in every class of baseball, from cow pasture to professional. He became an Atlanta fireman after playing pro ball with organizations such as the Phillies and Dodgers. During World War II, his baseball salary was $600 per month. Other Powder Springs baseball notables are umpire J.B. "Red" McCutcheon, Homer Hobbs, and A.W. Young. (Courtesy Eunice Webb.)

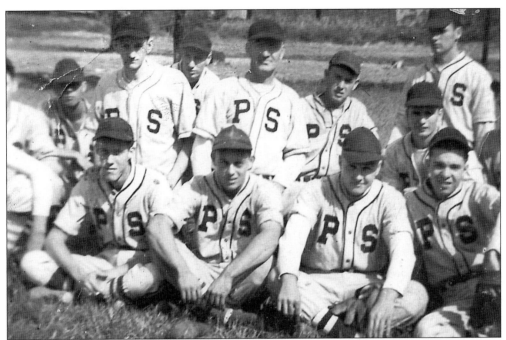

Powder Springs has always had a baseball team. The 1947–1948 team members are, from left to right, (front row) George Roberts, Pete Hardy, Lynn Spratlin, and Harold Duke; (back row) Ty Porter, Marion McTyre, J. Alton Keith, Coach Hugh Poore, Waymon Eidson, Harold Moon, and Carl Moon.

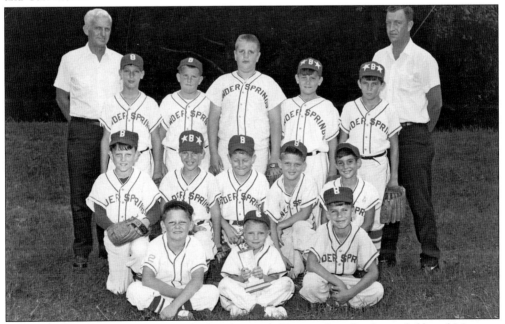

The Powder Springs Bears are pictured with Coach Tommy Ray (back row left) and Manager Johnny Eidson (back row right) in an undated photograph. Baseball is still the top sport in town, and Powder Springs Park features several well-maintained ball fields. A parade is held each year to officially open the baseball season in Powder Springs.

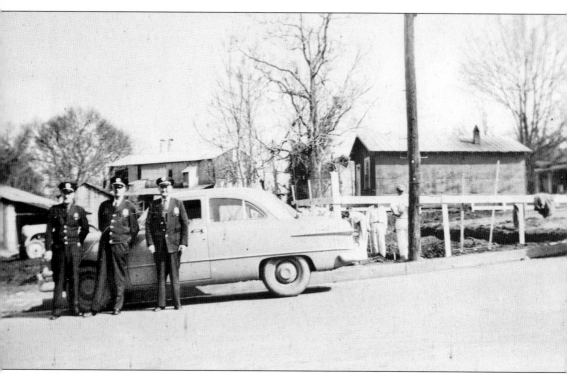

The Powder Springs Police Department is pictured in the late 1940s. McTyre's Cotton Gin is in the background. Notice the convict laborers to the right of the police car. Residents do not remember any serious crime in the town. There was, however, the occasional sighting of someone intoxicated on moonshine. (Courtesy Georgia Division of Archives and History, Office of Secretary of State.)

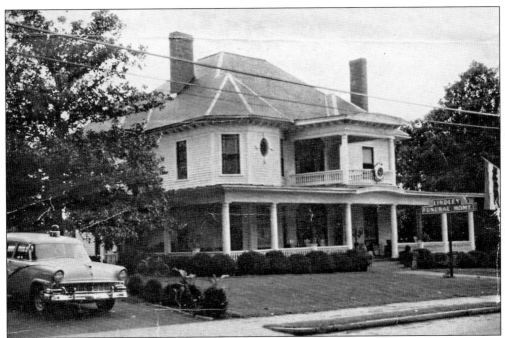

In 1953, Lindley's Funeral Home moved from the Lindley-Calloway House to the Walker Florence House pictured here. Residents remember the funeral home's horse-drawn hearse (first used in 1899 by Tom Lindley) with its glass sides and black fringe drapes. Now known as Bellamy's Funeral Home, the business is owned and operated by Dennis Bellamy. Uriah Matthews founded the town's first funeral home in the 1850s.

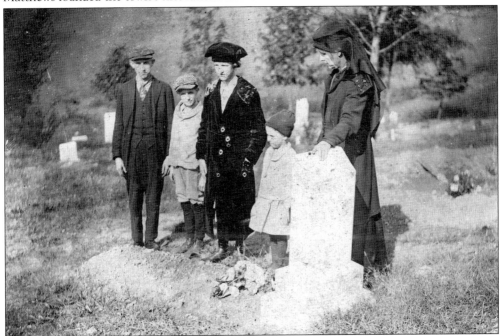

In this undated photograph, a family mourns at the gravesite of a loved one in Baptist Cemetery. Note the woman's mourning veil.

The Powder Springs Hospital, pictured in the late 1950s, was a humble facility on Atlanta Street. Dr. J.A. Griffith, the hospital physician, lived next door. Today the building houses a preschool operated by the First Methodist Church. (Courtesy Georgia Division of Archives and History, Office of Secretary of State.)

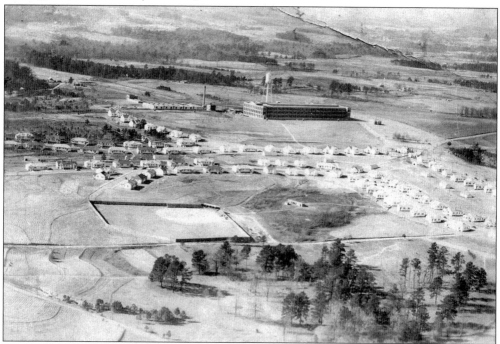

This postcard from the 1930s shows an aerial view of Coats and Clark Thread Mill and the village that grew around it. The mill operated for 50 years and employed 650 citizens. Located in the Clarkdale community, the mill is now a retail and municipal facility.

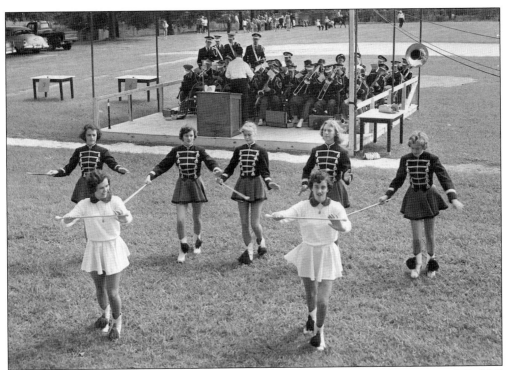

The 25th anniversary of the thread mill was an occasion of great celebration in 1958. Mill employees and their families enjoyed games, majorettes, speeches, and mouth-watering barbecue. The event made the news that day on Atlanta's WSB Radio.

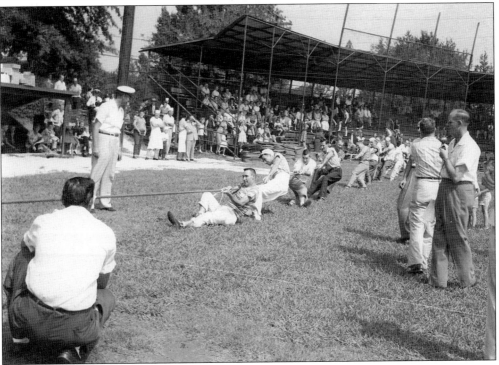

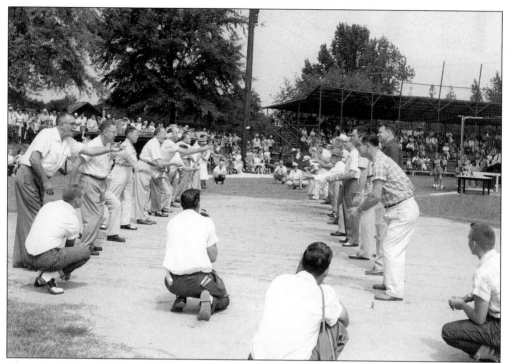

The Clarkdale ball field was the location of the Coats and Clark anniversary celebration in 1958. The crowds cheered from the bleachers and sidelines as games such as the egg toss, pictured here, were played. Residents and former employees remember Coats and Clark with great fondness. The mill closed its doors in 1983.

Three young beauties celebrate their second place win in the 1959 Cobb County parade float contest. They are, from left to right, Ann Cole, Coranne Mellichamp, and Sandra Pudlow. Fire Chief Tommy Ray, at right, helped build the winning Powder Springs float.

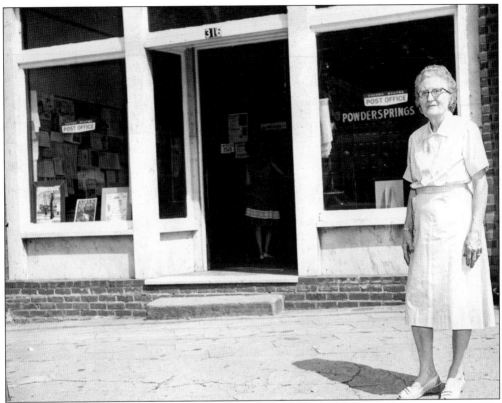

This photograph of Estelle Leake Tapp was taken in 1962 when she retired as postmaster. She had worked at the downtown post office for 29 years. During the war years, she recalled working from 6 a.m. to 9 p.m. The old post office building is now home to an antiques and gift shop called the Puddle Duck Cottage. (Courtesy Georgia Division of Archives and History, Office of Secretary of State.)

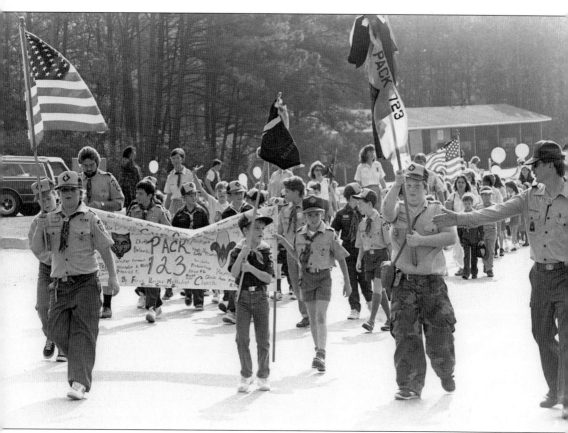

This photograph of Cub Scout Pack 123 was probably taken around 1984. Among those in the photo are Jimmy West, Kirk Plunkett, Ryan Lott, Ashley Paschel, Roger Lewis, and Clint Willis. Despite tremendous population growth, Powder Springs has retained its small-town heart. Cub scouts, baseball, and parades are still part of the community fabric.

Four
COMMUNITIES OF FAITH

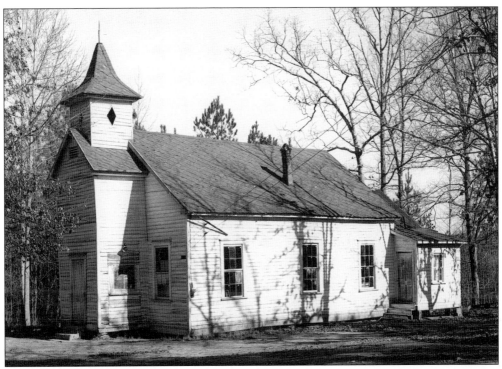

Old Friendship Baptist Church, an early black church, was organized in 1854 by slaves. Before they were freed in 1865, the slaves worshiped in a brush arbor on land donated by Jim Hardage, a plantation owner. Pictured here is the original clapboard church that served its members for more than 100 years.

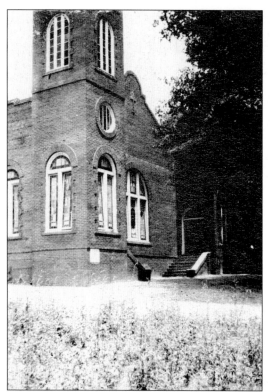

The First Baptist Church is pictured in 1914. Established in 1841, the church was first located on the edge of the Baptist Cemetery. In 1864, Union troops dismantled the church and used its lumber to build barracks in a nearby orchard. In 1877, a building was erected at the present site on Marietta Street. The white-frame building was lighted with swinging kerosene lamps and heated by two pot-bellied stoves. The brick building pictured here was constructed at a cost of $4,400 in 1914 and could seat 500 people.

The interior of the First Baptist Church reveals the large stained-glass windows that were imported from Germany. The windows were donated to the church as memorials to M.C. Kiser, Will D. Upshaw, and Louise Scott Hardage. Although a modern sanctuary replaced this one in 1965, the windows continue to be used today. The current church building was designed by William R. Tapp Jr.

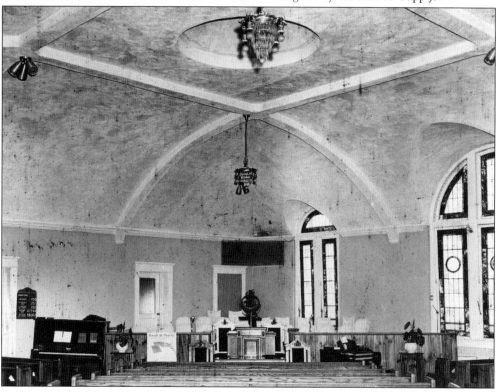

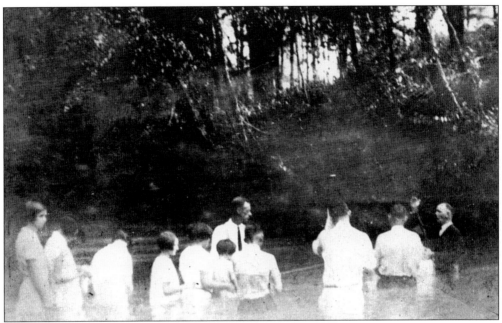

A First Baptist Church minister performs a baptism in Powder Creek in 1928. The church has been known by several names throughout its history: Springville Baptist Church of Christ, First Missionary Baptist Church of Powder Springs, and Powder Springs Baptist Church. (Courtesy Georgia Division of Archives and History, Office of Secretary of State.)

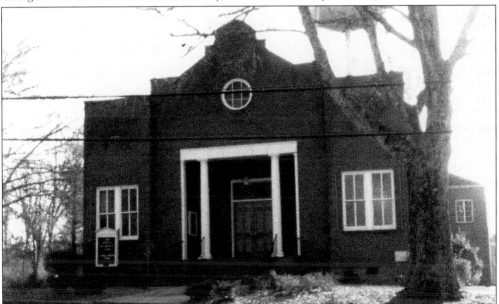

Established in a log cabin in 1838, the First United Methodist Church moved to its present location in 1844. The sanctuary pictured here was completed in 1924. The water tower in the background was for an artesian well dug in the 1930s. The historical record of the church states that Union soldiers burned down the church in 1864. The Baptist history offers a different account; it says that the Methodist church was dismantled and the lumber hauled away. A fellowship hall and new sanctuary were erected in recent years.

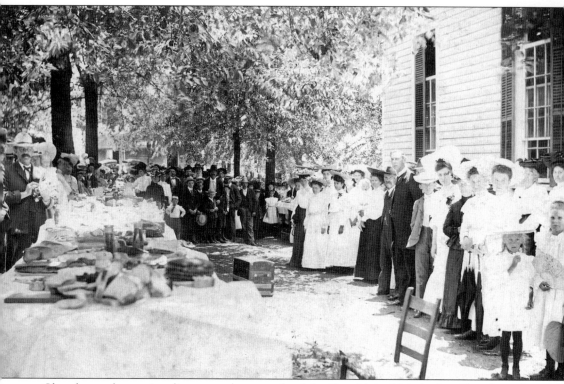

Church members enjoy dinner on the grounds of the First United Methodist Church in this photograph from the early 1900s. At that time, the church was a two-story, white-frame building with green shutters and a belfry. The Methodists tolled the bell when a deceased community member was being taken to the cemetery. The bell was tolled the same number of times as the number of years the deceased had lived. The church building had a long porch across the front, and the upstairs served as the Masonic Hall.

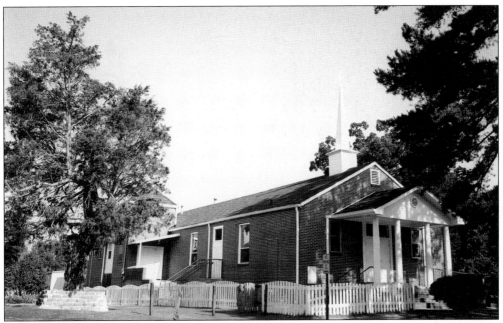

New Hope Missionary Baptist Church was founded in 1867 under the leadership of Rev. Seaborn Rucker. For three years, the congregation worshiped under a brush arbor. New Hope is a landmark church in the African-American community. Other early African-American churches are Macedonia Baptist, New Friendship Baptist, and Bethel Baptist.

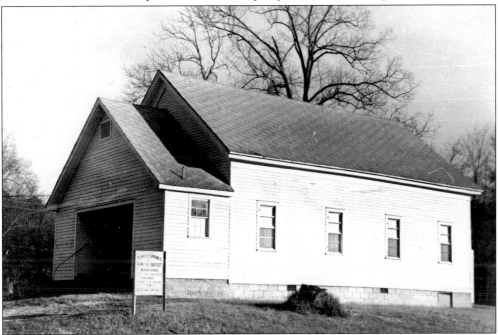

The Primitive Baptist Church was established in 1851. According to Rev. Harry Meek's *History of the Concord Association*, this church and the Springville Baptist Church of Christ had their beginnings in a Baptist church founded in 1835. Some members of that church left over a matter of doctrine and formed the Primitive Baptist Church. (Photo by David B. Furber.)

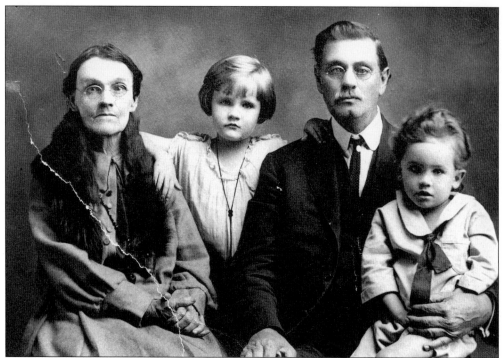

W.T. Walden, pictured with his family in an undated photograph, was pastor of the Primitive Baptist Church for 40 years. According to the late Virginia Tapp, "Religion has been a mighty force in the history of Powder Springs. All of the churches have had some strong, forceful ministers."

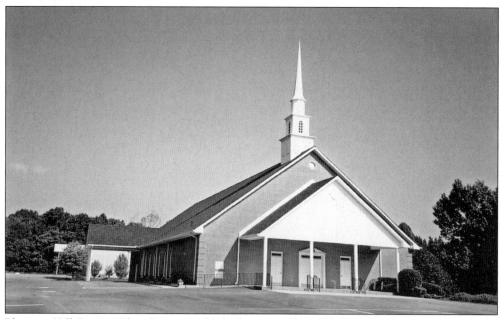

Pleasant Hill Baptist Church was established on June 7, 1850. In 1991, lightning struck the steeple and the church burned to the ground. The church purchased the property across the street and built a new church (pictured here) on this site. The new building was dedicated in 1992.

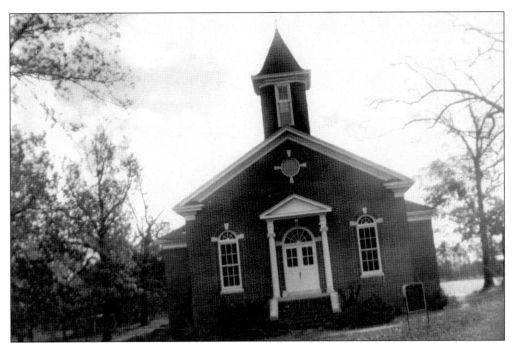

McEachern Memorial United Methodist Church was organized in 1837 as Ebenezer Campground, becoming part of the Powder Springs Methodist circuit three years later. In 1932, the present sanctuary was built as a memorial to John Newton McEachern, and the congregation changed the church's name. McEachern was co-founder of the Life of Georgia Insurance Company. His widow, Lula Dobbs McEachern, and the Life of Georgia board members donated half the cost of building the sanctuary. Endowment funds from Mrs. McEachern's estate have been used to make enhancements to the church's facilities and programs.

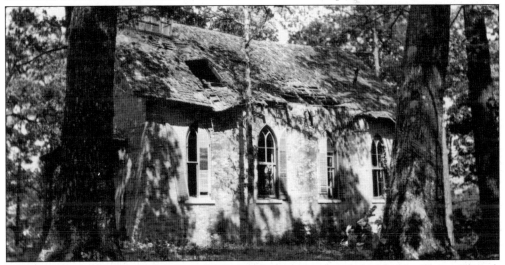

In 1886, some neighboring families of different faiths constructed the Nesbitt-Union Chapel. They built the chapel to use as a gathering place for worship, education, and community events. The rock chapel had a picturesque steeple with a bell and Gothic windows. Services were held on rotating Sundays by Marietta churches of four different denominations. Over the years, the chapel fell into disrepair. (Photo by W.R. Tapp Jr.)

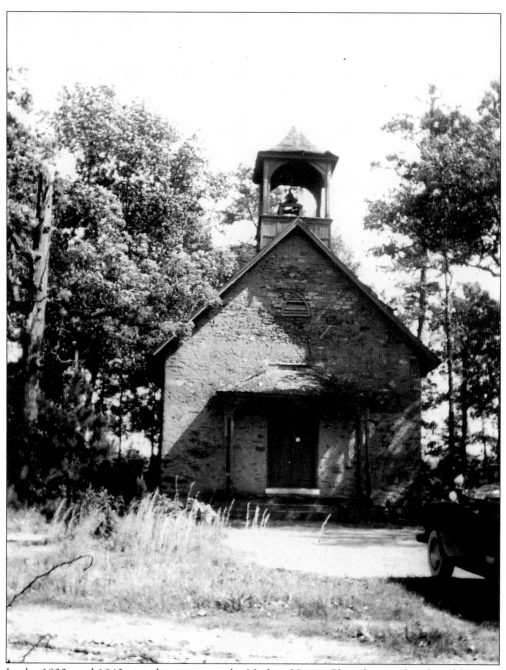

In the 1930s and 1940s, inside services at the Nesbitt-Union Chapel were abandoned because of the deteriorating condition. Nevertheless, the chapel site became a favorite spot for outdoor church camp meetings, for which tents would be set up for several weeks on the grounds. In 2004, most of the remaining chapel ruins were bulldozed as a result of an ownership dispute. (Photo by W.R. Tapp Jr.)

Five
THE CIVIL WAR

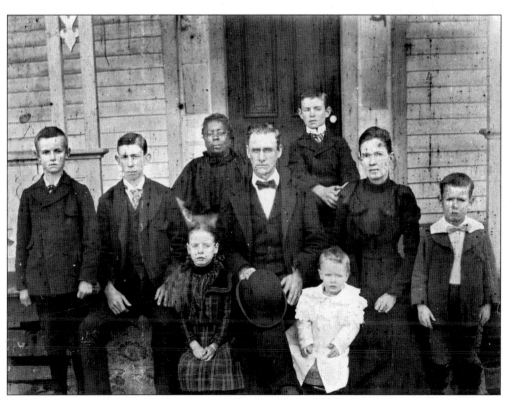

U.S. Major General Stoneman used Jim Lindley's parlor as his headquarters. Lindley is pictured with his family and Dessa Florence (back row, third from left), their maid. Union soldiers tore down the Methodist and Missionary Baptist Churches and hauled the lumber to the Lindley home to build quarters.

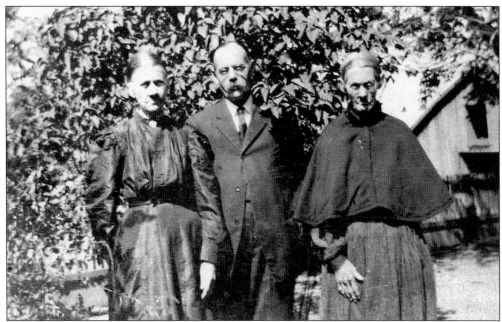

Members of the Lindley family, pictured from left to right, are Jane, Tom, and Tom's mother, Asenath. Tom's father, Jonathan Lindley, was a Confederate soldier who was captured and died as a prisoner of war at Camp Chase, Ohio.

During the Civil War, Asenath Lindley lived in this house near Noses Creek with her five children. Union troops fired shrapnel into her home as she sat rocking her son Tom. He was blinded in one eye by the shrapnel. On another occasion, Mrs. Lindley spied a Yankee's blue uniform through a crack in the cabin floor. She walked quietly over to the wood burning stove and picked up the black iron kettle. Tiptoeing back with the steaming hot water, she poured it through the crack and scalded the Yankee's back.

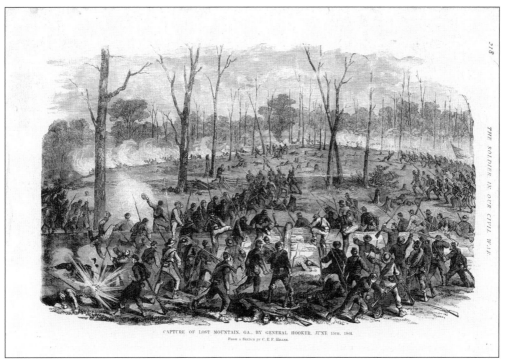

CAPTURE OF LOST MOUNTAIN, GA., BY GENERAL HOOKER, JUNE 15th, 1864.

FROM A SKETCH BY C. E. F. HILLEN.

THE SOLDIER IN OUR CIVIL WAR

This 1890 drawing, from *The Soldier in Our Civil War*, depicts the capture of Lost Mountain on June 15, 1964.

William Henry McDonald (1844–1928) is pictured with his wife, Mary Ann Clifton Landrum (1847–1926). In November 1862, McDonald joined the 63rd Georgia Regiment, where he served with James Landrum, his future father-in-law.

After the Civil War, William Henry McDonald became a farmer and lived with his family in this house on Atlanta Street. McDonald was the father of Fred McDonald, a town merchant.

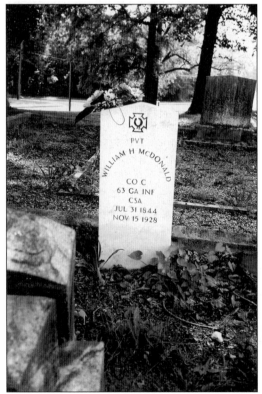

William Henry McDonald's military service is commemorated on this tombstone in the Baptist Cemetery. His regiment saw brutal hand-to-hand combat at the Battle of Kennesaw Mountain on June 27, 1864. According to a Union commander's report, "After a desperate hand-to-hand fight, in which the bayonet and butts of muskets were used, we succeeded in capturing their works . . . The rebels fought with a desperation worthy of a better cause."

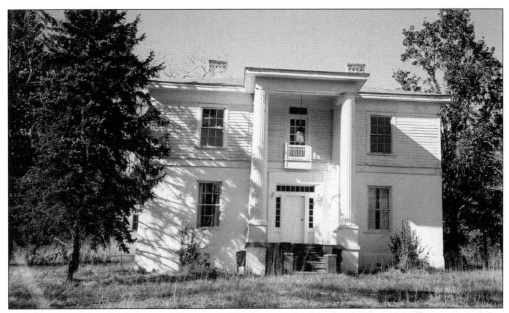

In late June 1864, the Cheney-Newcomer House was the headquarters of U.S. Maj. Gen. John Schofield, commanding the Army of the Ohio, right wing of Gen. William T. Sherman's forces. Cox's 3rd Division camped here and supported Hascall's 2nd Division near the McAdoo House in the nearby Battle of Kolb's Farm. The upstairs was used as a hospital for the Union soldiers, and bloodstains can still be seen.

The Cheney Family Cemetery, now overgrown and unattended, lies on a corner of the Cheney-Newcomer property. Five members of the Cheney clan, including patriarch Andrew Cheney (1815–1886), rest in the cemetery. The Cheney-Newcomer House appeared on the Union Army's war maps of 1864 for the Atlanta Campaign.

Confederate and Union forces saw fierce action at the Kolb House on June 22, 1864. The loft of the house was used for observation and as a post for Federal sharpshooters. This annoying gunfire caused the Confederates to fire on the house. Gen. Joseph Johnston's artillery shot the roof off. The kitchen and slave quarters were burned.

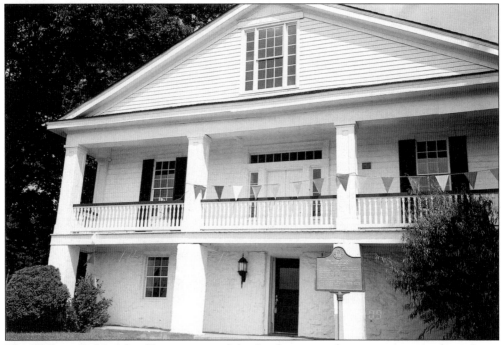

The William G. McAdoo House is one of the few houses in the area to survive the military operations of the Kennesaw Campaign. It was owned by the McAdoo family from 1863 to 1864 and is the birthplace of William Gibbs McAdoo, secretary of the treasury under President Woodrow Wilson; senator from California; and Democratic presidential nominee (1920 and 1924).

Thanks to the efforts of Josie Kiser Autry, pictured here, the Methodist and Missionary Baptist Churches were reimbursed for the destruction caused by the Union troops. In 1915, the churches received a $640 check from the federal government.

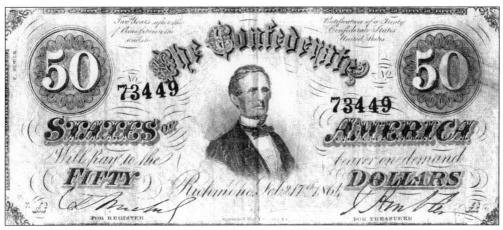

This $50 Confederate bill was printed on February 17, 1864, in Richmond, Virginia, the capital of the Confederate States of America. The bill is just one of many Civil War items on display at the Seven Springs Historical Society & Museum.

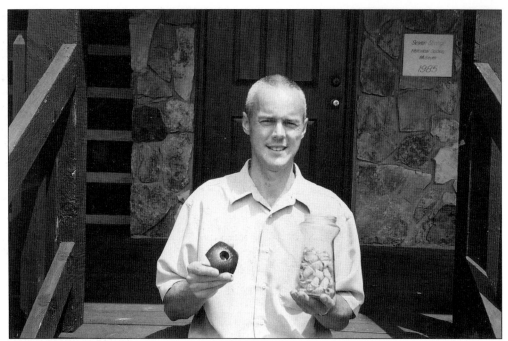

Jeff Jerkins, a local Civil War relic hunter, poses with a few of the items from the museum's Civil War Room. Over the last few years, Jerkins has found thousands of relics in and around Powder Springs. Some of his most unique finds, such as a bullet whittled into a chess piece, are on exhibit at the museum.

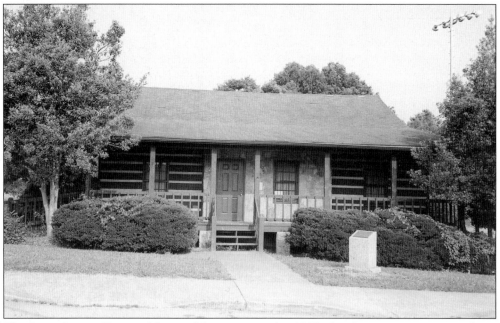

The Seven Springs Historical Society Museum opened in 1985 after the society was organized two years earlier. The museum, located in Powder Springs Park, houses Indian artifacts, Civil War relics, farm equipment, domestic items, business machinery, furniture, and railroad mementos. The Mimosa Garden Club maintains an herb and butterfly garden behind the museum.

Six

AT WORK

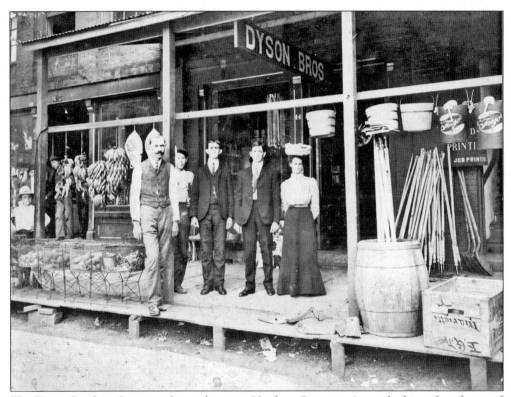

The Dyson Brothers Store was located next to Hardage Groceries (note the bins of produce and hanging clusters of bananas on the left). The individuals are identified, from the center to right, as Ellie, Cliff, and Truth Dyson. The Dysons must have left town before 1920, as there is no one by that name listed in the 1920 Powder Springs census. (Courtesy Georgia Division of Archives and History, Office of Secretary of State.)

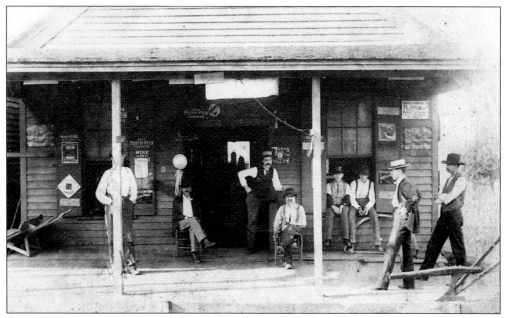

Oscar Hipp operated this store from 1881 to 1896. The business is listed as Hipps and Duncan Store in the *Georgia State Gazetteer, Vol. II, 1881–82*. Many of the signs on the storefront advertise tobacco.

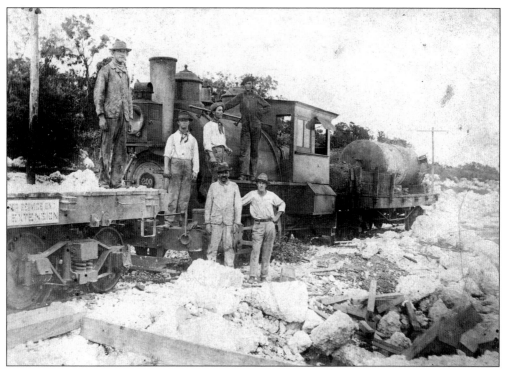

Railroad workers pause for an undated photograph taken in the Powder Springs area.

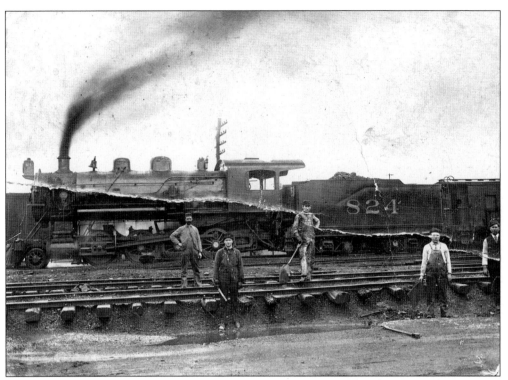

The Southern Railroad came to the community in 1882. The Seaboard Railroad was completed in 1905. A boon to the economy and transportation, the railroads helped define Powder Springs as a major agricultural center and recreational destination.

John Butner (left) and a young friend stand in front of the Lewis Cotton Gin on Atlanta Street. With 800 bales produced each year, cotton was king in Powder Springs until the boll weevil's appearance in 1915.

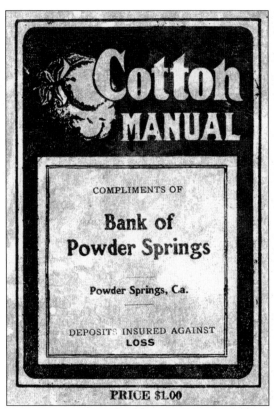

COMPLIMENTS OF

**Bank of
Powder Springs**

Powder Springs, Ca.

DEPOSITS INSURED AGAINST
LOSS

PRICE $1.00

This *Cotton Manual*, a book of cotton seller's tables, came compliments of the Bank of Powder Springs. The advertisers in the manual promote an array of products such as botanic blood balm, typewriters, and stump-and-grub pullers. An advertisement for a sanitarium in Atlanta promises to cure "opium, whisky, and other drug habits" in four weeks.

The McTyre Cotton Gin, owned by Charles Marshall McTyre, was a familiar part of the town landscape for many years. McTyre also operated a general store.

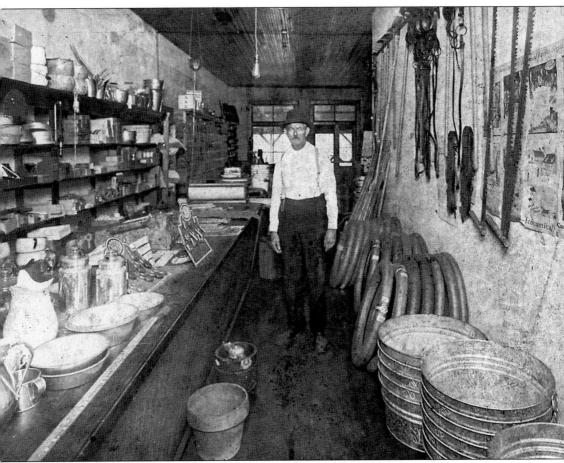

M.A.J. Landers is pictured in his hardware store around 1915. Landers also owned a construction company, a feed mill, and an automobile dealership. While mayor of Powder Springs, he initiated the first city-owned water works in 1934 with a $12,000 loan that he backed with his own money. When a disastrous tornado struck Gainesville, Georgia, in 1936, he loaded his truck with beds, mattresses, and other essentials and delivered the items to the storm victims.

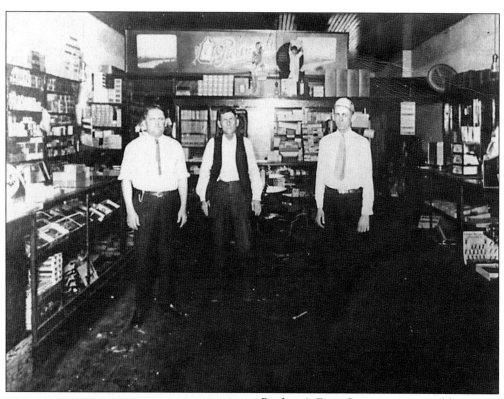

Bookout's Drug Store was operated by son and father, Henry Irvin (left) and Jessie Thomas Bookout (center), and Huborn Wilson. They are pictured here around 1915.

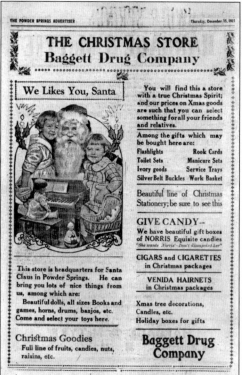

This 1921 holiday advertisement for Baggett Drug Company was printed in the *Powder Springs Advertiser*. Elsewhere in the paper was an ad for Hardage & McTyre General Merchandise; they were offering a sale on "men's good Union suits" for $1.50.

Oscar B. Jones built furniture in his blacksmith shop downtown. He was the father of Estie Norris, known over the years for her handmade quilts. Virgil Lovinggood, a Powder Springs merchant, remembered the sound of anvils ringing in the early morning air from the three blacksmith shops in town.

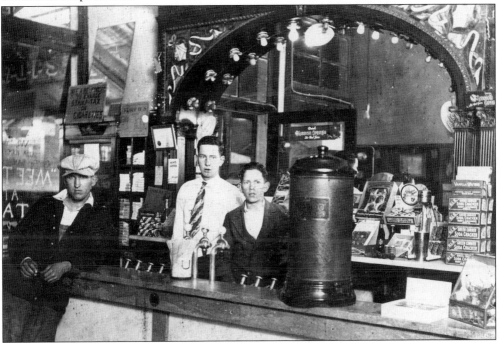

In the 1920s, Tapp Drug Store, with its marble counter, was a popular stop for Powder Springs residents.

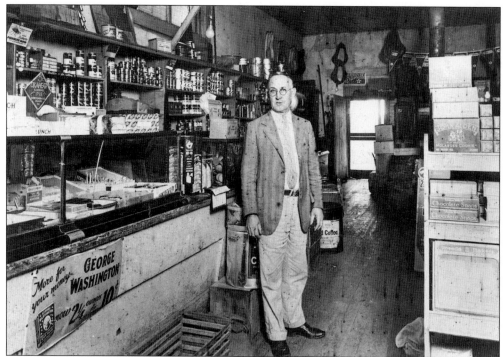

Fred McDonald is seen in his grocery store in an undated photograph. Notice the cans of Campbell's soup on the shelf at top left.

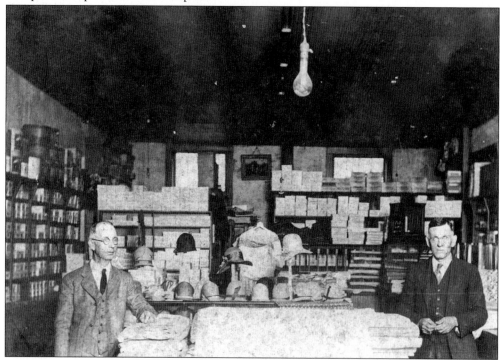

G.M. Hardage and W.W. Florence, two of the town's well-known businessmen, are seen in Hardage's Dry Goods Store.

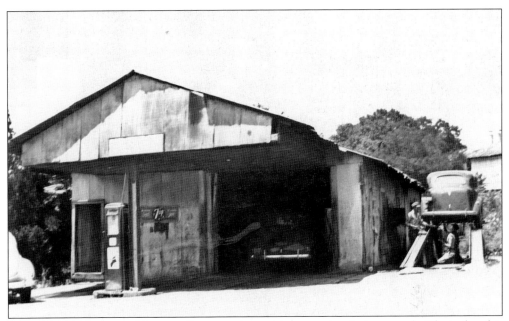

Earl Porter's Garage on Marietta Street is pictured in an undated photograph. These days his son operates a lawn mower shop at the site.

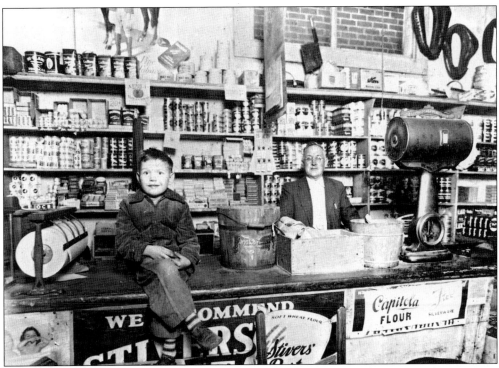

Parris McDonald sits on the counter at Fred McDonald's Grocery. There is an advertisement for Capitola Flour on the front right of the counter. The flour was named for Capitola Sims, a local resident.

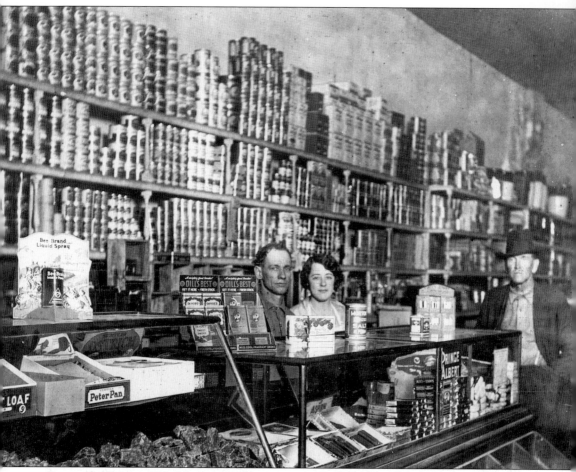

For nearly 50 years, Virgil Lovinggood's store was a place to buy all manner of goods and catch up on the latest news. Pictured from left to right are Lovinggood, Zora Compton, and unidentified. During the hard times of the 1920s and 1930s, some customers could not pay for their basic needs. One family paid Lovinggood $10.35 for a crate of eggs and a bushel of potatoes—35 years after he gave them the groceries.

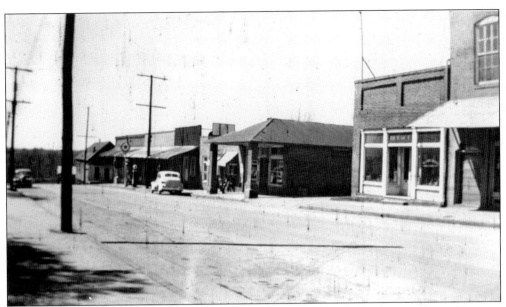

This view of downtown Powder Springs was taken in the 1940s. Today there is renewed interest in the downtown area, and the city is making aesthetic improvements to attract business and residents. (Courtesy Georgia Division of Archives and History, Office of Secretary of State.)

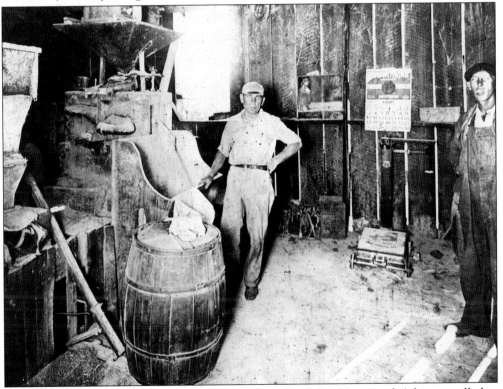

Murray Landrum, at left, is pictured in his grist mill. Helen Hammond Adrian recalls her grandmother sending her to the mill with instructions to "tell Mr. Landrum to grind the corn extra fine."

This undated photograph speaks to the rural small town that was Powder Springs. The businesses pictured, from left to right, are Earl Porter's Garage, the Delco Light Building, and McTyre's Gin.

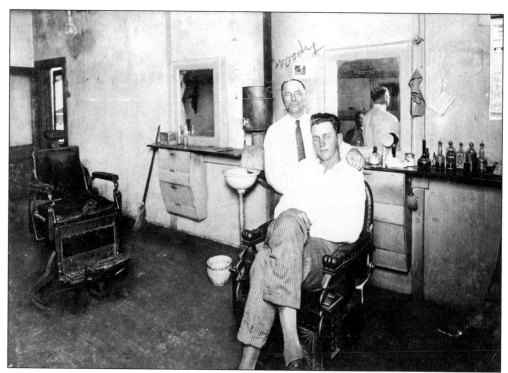

Woody Forrester is pictured with a customer in his barbershop in an undated photograph.

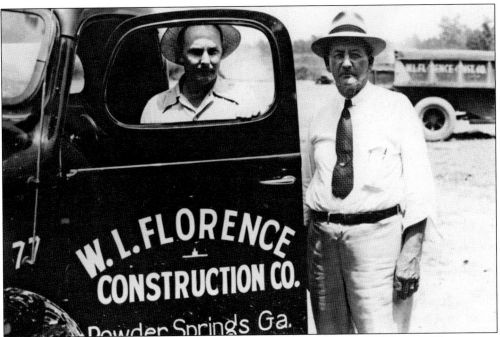

H. Harold Jackson (left) and W.L. Florence are pictured in 1941 on Highway 41. The runways for the Bell Aircraft Corporation (now Lockheed Martin) and Highway 41 were completed by Florence Construction Company. The caption on the back of the photograph boasts that the company "owns a fleet of 'Caterpillar' diesel tractors and engines."

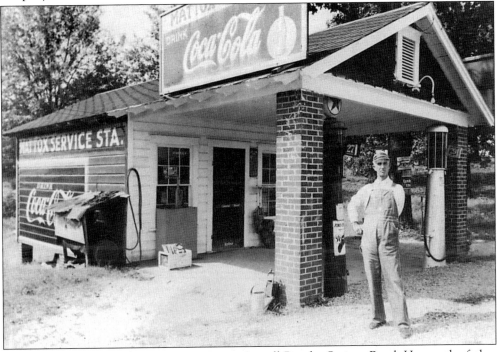

Lonnie Mattox operated a service station on Austell Powder Springs Road. He was the father of Velma Brady.

In this undated photograph, Lease James stands in front of his Pure Oil Filling Station and store on Old Austell Road.

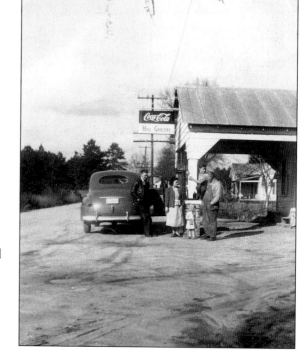

O.L. "Ollie" Hill owned Hill Grocery on Old Lost Mountain Road. Pictured in 1950, from left to right, are Wofford Maddox, Hill's son-in-law; Viola Hill Maddox, Hill's daughter; Judy Williams, his great granddaughter; Marvin Hill, his son; and Ollie Hill.

Seven

GOLDEN-RULE DAYS

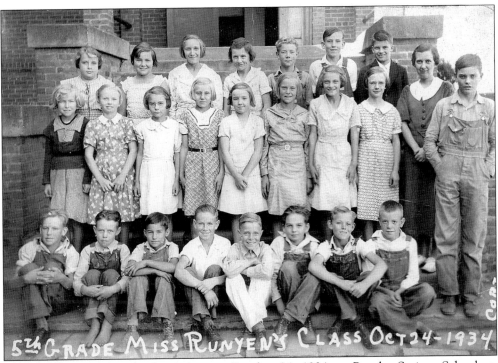

Miss Runyen's fifth-grade class poses on October 24, 1934, at Powder Springs School on Atlanta Street. The school served thousands of students from 1920 to 1988 and is a town icon. Today the school houses the Coach George E. Ford Center, a reception and meeting facility, and the Senior Citizens Center. Many residents hope that the beloved school will one day be restored and put to full use.

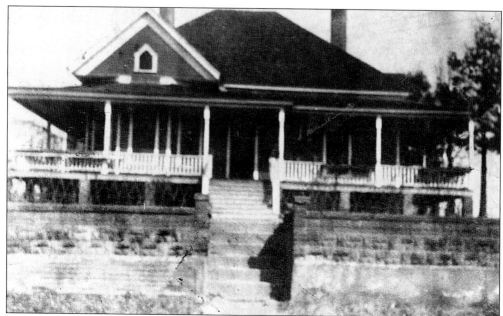

The Bernard Academy, a private boarding school, was an institution that enjoyed a good reputation during the early 1900s. Pictured here about 1906, the school was owned and operated by the Reverend and Mrs. Jesse Bookhart. Pupils attending this school included Louise Tapp, Chester Daniel, Minnie Moon, Nell Middlebrooks, Ethel Lindley, and Ethel Butner. The Bernard Academy was located at the site of La Parilla's Restaurant on Powder Springs Road.

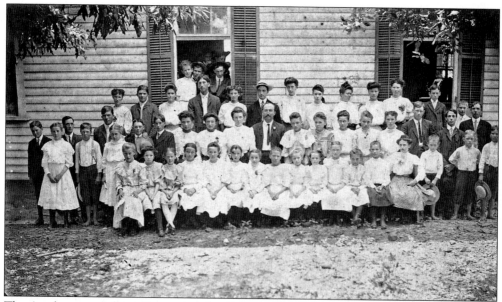

The Academy on Atlanta Street served students before the opening of Powder Springs School in 1920. The early settlers brought with them a desire for good schools. On December 19, 1840, Springville Academy was chartered to serve the children of the town. The Springville Academy was located adjacent to the Baptist Cemetery. Later it was moved to Atlanta Street, where it was known simply as the Academy.

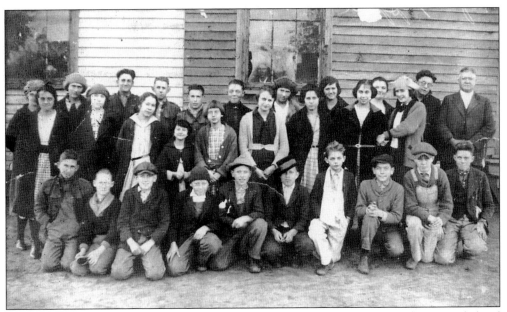

Back in those pre-plumbing days, Academy students would fetch water from the spring behind the school. Pictured, from left to right, are the following: (front row) Toad Leake, Hearst Meek, Carl McKenney, unidentified, Clinton Hill, Bobby Lee Bennett, Tommy Compton, Eston McTyre, and two unidentified; (middle row) Ruby Petrie, unidentified, Mamie Allgood, Hattie Compton, Tommy Love Burnett, Homer Moss, Flora Hill, unidentified, Corrinne Lawler, and Merle McTyre; (back row) unidentified, Willa Bowdon, Gerald Moore, Howard Moss, two unidentified, Pauline Putnam, two unidentified, Kirk Brown, and teacher Mr. Tippens.

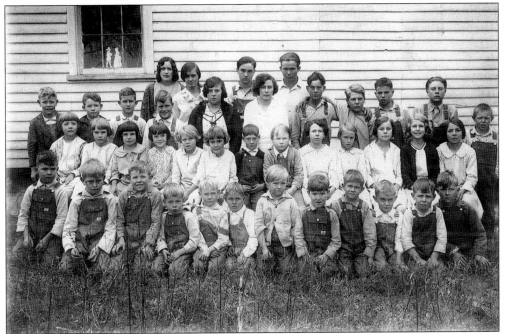

Rehobeth School students are pictured in an undated photograph. Notice the paper dolls in the window. The school was located near Angham and Hiram-Lithia Springs Road.

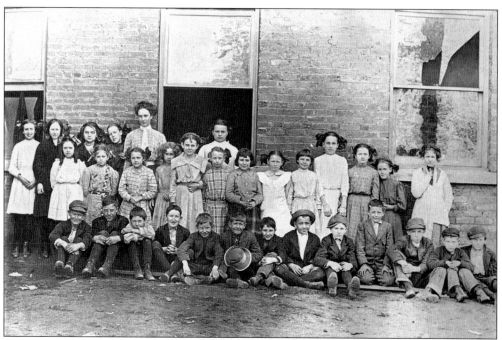

Roberta Murray's students at Kennesaw Home School are pictured in 1911. Murray, known as Powder Springs's first historian, began her professional life as a teacher in 1903 at the Macland McEachern School. From 1909 to 1915, she taught in the schools at Acworth and Kennesaw.

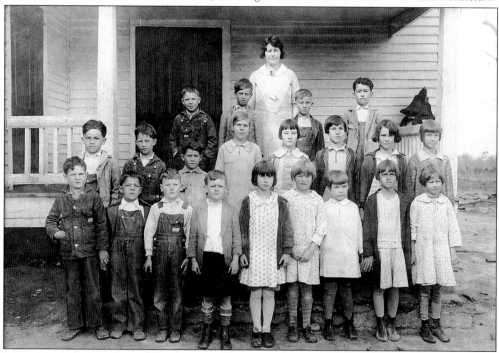

Mina Mae Echols's class at the Corner School is seen in an undated photograph. The school bell rests near the top right of the photograph. The Corner School was located near the McEachern High School campus.

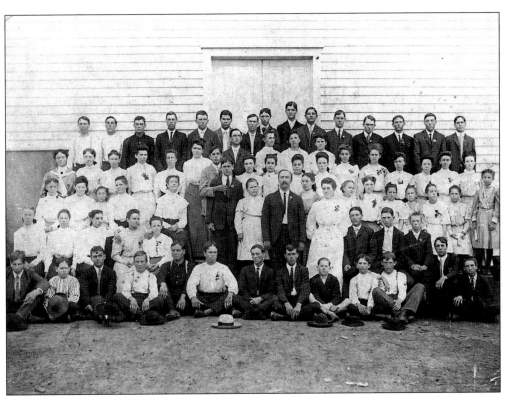

B.B. Beal's Singing School was located in Pleasant Hill.

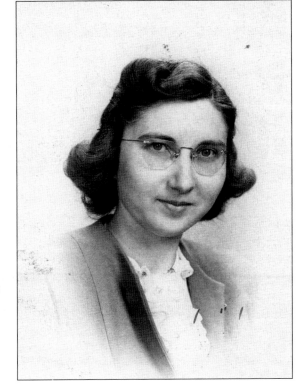

Sarah Frances Miller, pictured in 1947, was a teacher at Powder Springs School for many years. She touched the lives of several generations of students. An educator through and through, she made it her mission to preserve, collect, and communicate the history of Powder Springs.

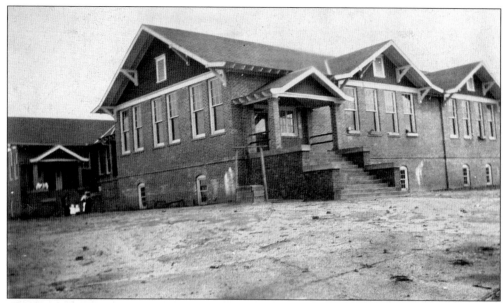

The Powder Springs School was originally built in a U-shape and, through the years, was enlarged to meet the needs of the students and community. The first school lunch program in the county was established at Powder Springs School and sponsored by the PTA. Around the year 1935, additions included a gymnasium, more classrooms, and an agricultural building. The primary building was added in 1957.

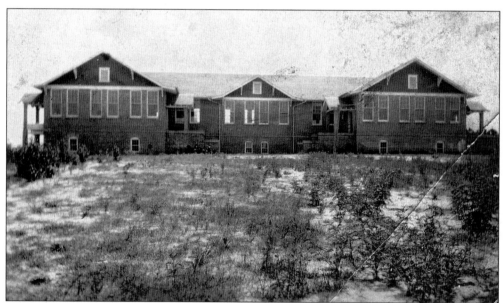

Until the 1952–1953 school year, Powder Springs School consisted of grades 1 through 11. In 1953, South Cobb High School opened, and Powder Springs High School students migrated to South Cobb. This left Powder Springs School as an elementary and junior high school. Eventually the school would just offer grades 1 through 5.

The members of W.P. Sprayberry's 10th-grade class are pictured in 1935. They are, from left to right, as follows: (front row) W.P. Sprayberry, Sarah Frances Miller, Harold Thomas, and Anned Jones; (back row) Oraline Roberts, Jack Baggett, Frances Cornwell, and Robert Turner.

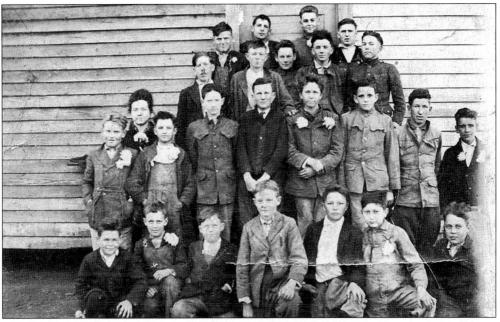

Mrs. Byrd's class at the Academy is pictured in an undated postcard. They are, from left to right, (front row) Harrison Scott, Fred Algood, Ben Oglesby, Pinky Jennings, J.R. Kirkendall, Ward Cole, and George Pate; (second row) Jim Huggins, unidentified, Ernest Williams, Gerald Moore, Leroy Oglesby, unidentified, Leonard Hight, and unidentified; (third row) Clement Lowler, Grady Lowler, Fred Brady, and Clyde McCurd; (back row) unidentified, ? Algood, Floyd Mobley, and ? Algood.

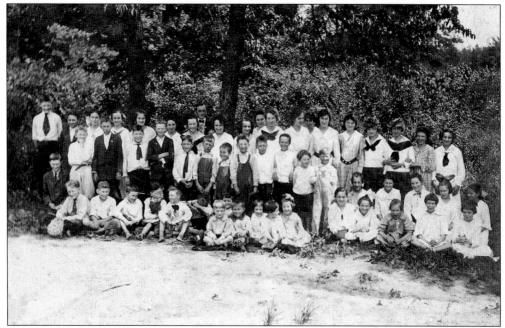

Hugh Moore was principal of Powder Springs School when this undated photograph was made. In the days of segregation, black students attended New Hope and Liberty Hill Schools. New Hope School became an elementary school after the county made arrangements for older African-American students to attend Lemon Street School in Marietta. The first black school in Powder Springs was a two-story building located at the site of Happy Valley Trailer Park.

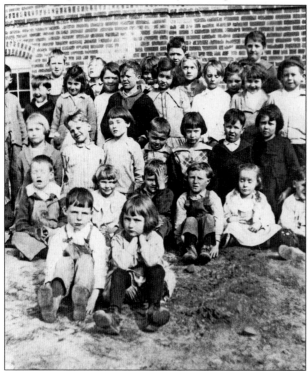

Powder Springs School students are pictured outside of the school in an undated photograph. Among those in the photograph, in no particular order, are James Mann, Dottie McTyre, Ann Holbrook, Bill White, Martha Rice, H.C. McTyre, Mildred Williams, Bruce Mann, Merle Hilley, Braucon Wood, Runell Hendrick, Joe Smith, Bula Mae Puttman, Frances Hilley, Dorris Baggett, Louise Garrett, Elizabeth Holbrook, J.B. Bean, and Bessie Mae Elrod.

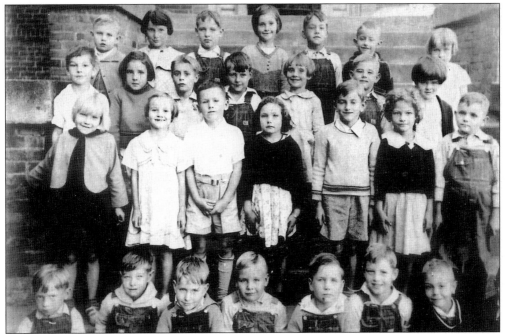

Miss Dumas's first graders at Powder Springs School are pictured, from left to right, as follows: (first row) Bill Waters, Lewis Furr, Edwin Puckett, Edward Porter, Troy Woodall, Lanier Craft, Cleaborn Jones, and Allen Mobley; (second row) Vivian Land, Virginia Thomas, Lewis Myers, Lettie V. Rogers, Marion McTyre, Dorothy Clinton, and Kenneth Cheatham; (third row) Neal Brewer, Dorothy McKinney, Dickie McCray, Grady Shuler, Kate Camp, Roy Ingram, and Margaret Hendricks; (fourth row) Claude Smith, Mary Lee Bowden, Robert Wehunt, Jessie Croker, Forrest Crow, Dennis Daniel, and Virginia Rice.

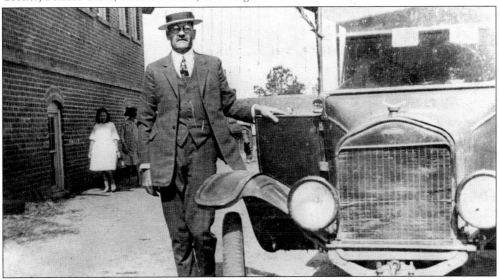

Mr. Self was principal of Powder Springs School in the 1920s. Powder Springs School reunions are still popular events—perhaps evidence of a line from the school's alma mater: "Our strong band can ne'er be broken, formed in Powder Springs High, far surpassing wealth unspoken sealed by friendships tie."

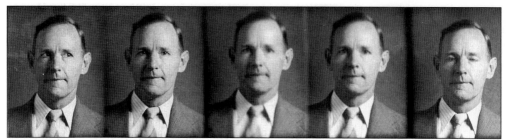

Lemuel E. Cox was a biology and vocational agriculture teacher at Powder Springs School. A vocational agriculture department was begun in the 1938–1939 school year, and the Future Farmers of America (FFA) Club became a popular student organization.

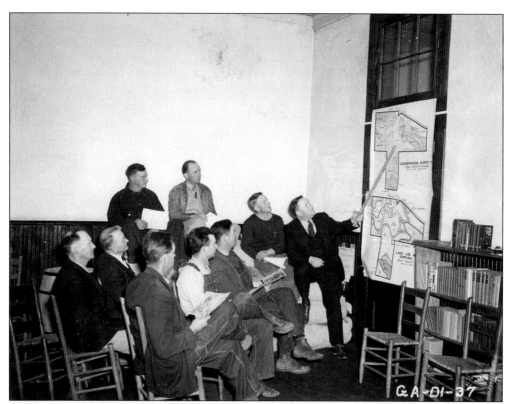

J.F. Cobb, at right, was a vocational teacher at Powder Springs School. He is seen assisting farmers in group planning in this 1941 photograph. The patriotic spirit was feverish at Powder Springs School during the war years. Superintendent Tom Fallaw told students in 1942, "Students who waste time at school, refuse to cooperate with other pupils and teachers, abuse school property, and behave selfishly are virtual enemies of America."

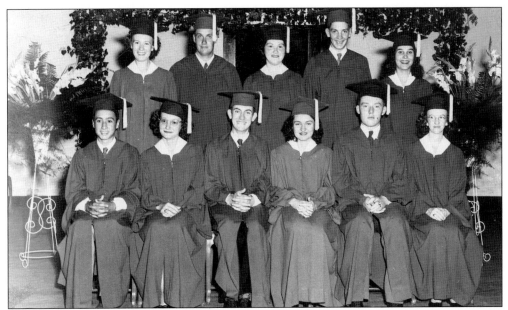

The Powder Springs High Class of 1949 is pictured from left to right as follows: (front row) James Moss, Imogene Hovers, Jerry Hill, Mary Lee Crane, Ralph Wheeler, and Elzie Thomas; (back row) Pauline Jordan, Oertel Abernathy, Rheba Lou Rich, Guy Camp, and Marjorie Cantrell. Not pictured are Ray McDonald and Bobby Keith. A school newspaper reporter noted that year that Oertel Abernathy's "main interest in life at the present is Imogene [Hovers]." They have been married since 1951.

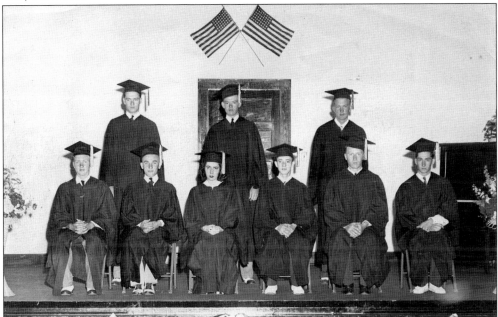

These Powder Springs High School students were under the tutelage of Mr. Nestlehutt. Pictured from left to right, they are as follows: (front row) Len Spratlin, Richard Adams, Myra Nell Hunter, Dillard Brown, Marvin Meadows, and Everett Furr; (back row) Harold Moon, Chalmis Nestlehutt, and James Hendricks.

Students enjoyed the simple playground behind Powder Springs School. The girls pictured in this photograph from the 1966–1967 school year are, from left to right, Carol Adams, Cynthia Cornwell, and Tammy Barnes.

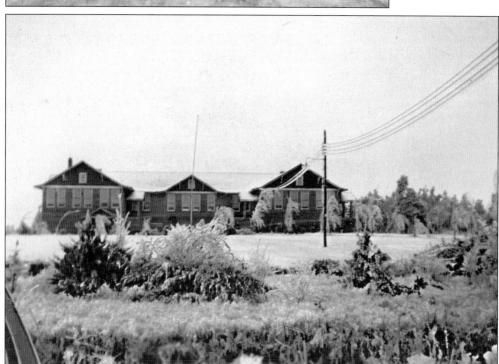

The front of the Powder Springs School building looked like this until changes were made to the exterior in 1967. Today there is a veterans' memorial and fountain in front of the building.

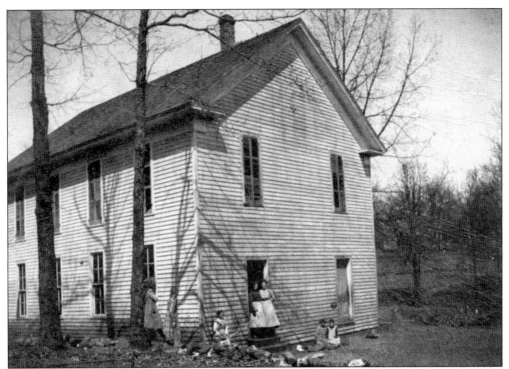

The Lost Mountain School was on the northwest corner of Lost Mountain Road and Dallas Highway. The school was located across from the Lost Mountain Store, a legendary part of the Lost Mountain community.

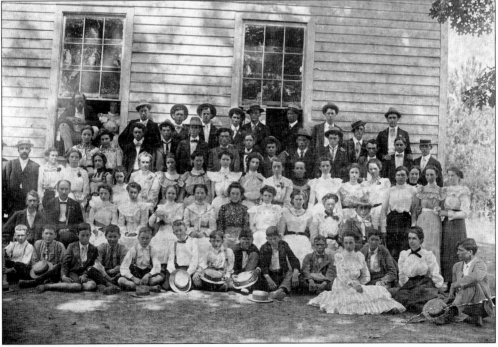

Students of Lost Mountain School are pictured in a photograph believed to be taken around 1900.

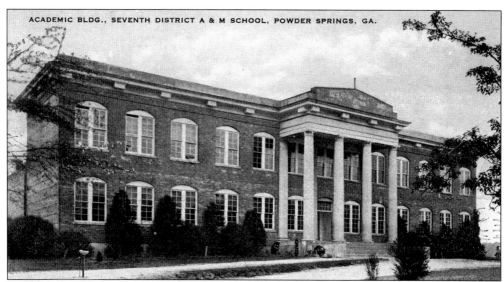

ACADEMIC BLDG., SEVENTH DISTRICT A & M SCHOOL, POWDER SPRINGS, GA.

The Academic Building of the Seventh District A&M School is seen in an undated postcard. The school opened in 1908 and was one of the most important educational institutions in the history of Powder Springs. John Newton McEachern's financial support and donation of 240 acres of land enabled the establishment of the school. The school is now known as McEachern High School.

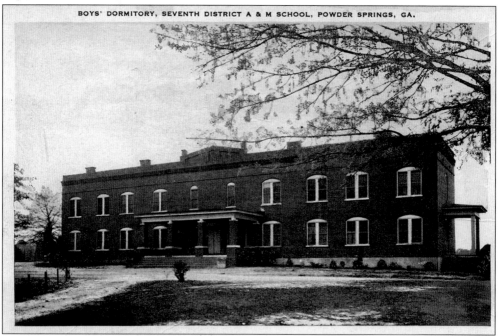

BOYS' DORMITORY, SEVENTH DISTRICT A & M SCHOOL, POWDER SPRINGS, GA.

The Boys' Dormitory, pictured here, consisted of 48 rooms. In its first year, the Seventh District A&M School enrolled 77 students. The boys cleaned the buildings, cultivated the crops, and cared for the livestock. The girls prepared and served all meals. Their work was credited towards the cost of board. From 1908 to 1933, the school served the needs of rural high-school students, enabling them to acquire an education that would have been denied them through the private school system.

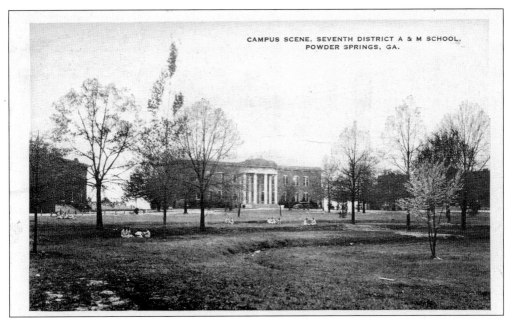

CAMPUS SCENE, SEVENTH DISTRICT A & M SCHOOL,
POWDER SPRINGS, GA.

Students dot the campus lawn in an undated postcard. Prof. Henry R. Hunt, the Seventh District A&M School's first administrator, literally built the campus from the ground up. The first bricks used in the construction of campus buildings were made from clay on the school's land and fired in a kiln that Hunt had built on the site. The school was located in Macland, a community that was already thriving by the time Cobb County was created in 1832.

Seventh District A&M students strike a collegial pose in a photograph from the 1920s. An annual school bulletin instructed students to "leave at home the following: cards, guns, pistols, intoxicating liquors, tobacco of all kinds, idleness, selfishness, laziness, profanity, and bad habits. Leave all of these at home and you will do well."

125

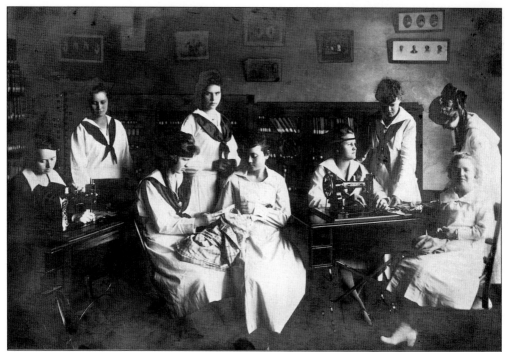

This photograph, believed to be of a sewing class at the Seventh District A&M School, was rescued from a dumpster by a local citizen. Each year, the school awarded a gold thimble to the senior girl who had the highest grade in sewing. The crowning project of the senior sewing class was to design, cut, fit, and make the graduation dress.

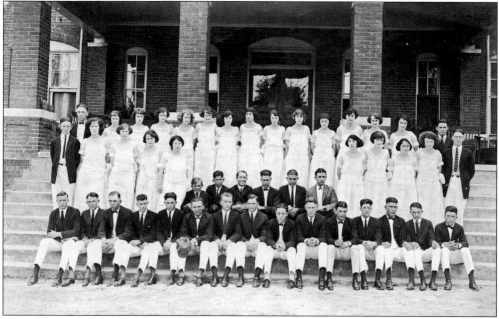

The class of 1923 looks ready to take on the world. Students of the Seventh District A&M School received a well-rounded education, with courses on everything from physics to livestock judging.

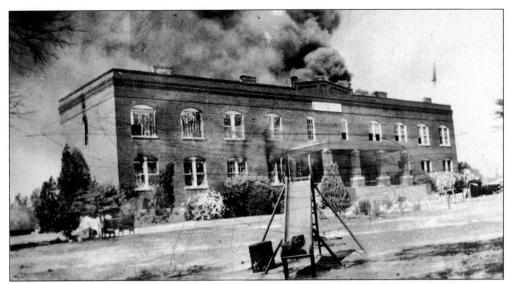

The Boys' Dormitory succumbed to fire in 1910 and was rebuilt in 1912. The Seventh District A&M School campus was beautifully landscaped by students and equipped with barns for horses and cows, a dairy barn, tennis and basketball courts, and a football field. Students also enjoyed boating and bathing in a nearby lake. (Courtesy Georgia Division of Archives and History, Office of Secretary of State.)

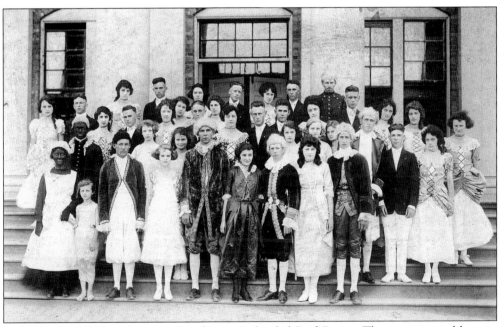

In 1921, the A&M students produced a musical titled *Paul Revere*. They are pictured here in costume. The school offered a wide range of student activities. The campus is now the site of McEachern High School, one of the finest high-school complexes in Georgia.

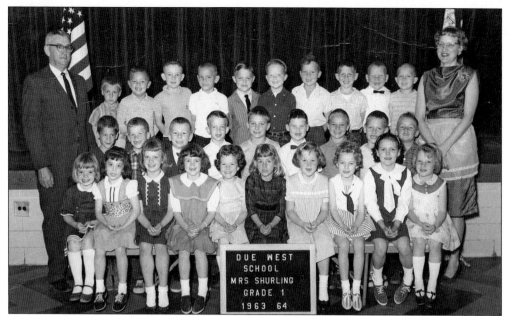

Mrs. ? Shurling's first graders at Due West School take a class portrait during the 1963–1964 school year. They are, from left to right, as follows: (front row) Lou Ann Whitner, Terrie Black, Nancy England, Jo Ellen Rooney, Jan Meek, Karen Bramlett, Kathy Pilgrim, ? Truelove, Mary Jane Littlefield, and unidentified; (middle row) Charles Perry, Hank Randall, Chris Corn, Reed Benson, Ricky Castleberry, three unidentified, and Bobby Wilson; (back row) Richard ?, David White, Ricky Cowart, Bruce Reed, ? Benson, David Kirk, Billy Higdon, Tommy Ford, and two unidentified.

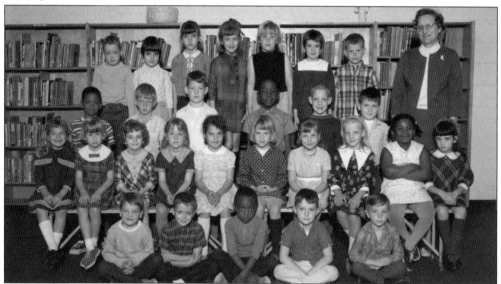

Mrs. ? Shurling taught these first graders in 1968 at the McEachern Schools. With the establishment of the University System of Georgia in 1933, the Seventh District A&M School was closed. In October of that year, the school was reborn as the Macland Consolidated School and shortly thereafter was named the McEachern Schools. In 1975, the school evolved into McEachern High School.